Better Available Light Photography

Joe Farace and Barry Staver

Focal Press
Boston Oxford Melbourne Johannesburg New Delhi Singapore

Focal Press is an imprint of Butterworth–Heinemann.

Copyright © 1999 by Butterworth–Heinemann

ℛ A member of the Reed Elsevier group

Recognizing the importance of preserving what has been written, Butterworth–Heinemann prints its books on acid-free paper whenever possible.

Butterworth–Heinemann supports the efforts of American Forests and the Global ReLeaf program in its campaign for the betterment of trees, forests, and our environment.

Library of Congress Cataloging-in-Publication Data
Farace, Joe.
 Better available light photography / Joe Farace and Barry Staver.
 p. cm.
 Includes index.
 ISBN 0-240-80335-3 (pbk.)
 1. Available light photography. I. Staver, Barry, 1948– .
 II. Title.
 TR590.F37 1999
 778.7′6—dc21
 98-35338
 CIP

British Library Cataloguing-in-Publication Data
A catalogue record for this book is available from the British Library.

The publisher offers special discounts on bulk orders of this book.

For information, please contact:

Manager of Special Sales
Butterworth–Heinemann
225 Wildwood Avenue
Woburn, MA 01801-2041
Tel: 781-904-2500
Fax: 781-904-2620

For information on all Butterworth–Heinemann publications available, contact our World Wide Web home page at: http://www.bh.com

10 9 8 7 6 5 4 3 2 1

Printed in the United States of America

Dedication

This book is dedicated to Fred Schmidt, former Editor-in-Chief for Photomethods *magazine. Many years ago when I was just a photographer, he turned me into a writer and forever changed my life. This book, and the nineteen others I have written, would have never happened without his kindness, friendship, and inspiration. Thanks, Fred.*

Joe Farace

This book is dedicated to my parents, Margaret and Harry Staver. When I was a teen, they allowed me to conclude music lessons, trade a guitar for an enlarger, and turn the basement into a darkroom. They patiently stood by as I acquired equipment and worked through to the wee hours making prints. They supported my decision to pursue photography when those around me were going off to "real" jobs. Thanks, Mom and Dad, for providing a starting place for a dream that has come true.

Barry Staver

Contents

Acknowledgments

We would like to thank the following individuals for their assistance with this book: Bill Craig for providing two of his available light images as well as his thumbnail sketch on how the Zone System works; Tom Davis of Saunders for product photographs of Benbo tripods and Polaris light meters; Steve Allessandrini of Bozell for product photographs of Minolta light meters. We also wish to acknowledge and thank *The Denver Post* for the right to publish several of their photographs.

Special thanks from Joe Farace: I would like to acknowledge the wit, wisdom, and photographic skills of Barry Staver. Without his hard work, talent, and good humor this book could never have been completed. The dramatic images he created for *Better Available Light Photography* are a testimony to his many accomplishments in the field of photojournalism. I am, indeed, honored to call him my friend.

Special thanks from Barry Staver to Joe Farace for his friendship, advice, and encouragement. His experience has provided the focus and inspiration necessary for creating images, being better organized, and meeting publishing deadlines. In addition to the world of photography, he has broadened my horizons in the computer and digital imaging fields, as well as in numerous other venues. Thanks, Joe.

Introduction

While learning and refining their skills, most photographers progress through three distinct phases. The first phase occurs immediately after they get their first "good" camera and begin discovering the potential of the medium. During this time, novice shooters photographically explore their world with a high level of enthusiasm. Every new batch of prints or box of slides they examine contains images that look much better than they ever imagined they would. Unfortunately, this blissful period doesn't last long and is quickly replaced by the next phase.

In phase two, the shooter's level of enthusiasm is still high but is diminished when reviewing his or her newest prints and slides only to discover that they are much worse than expected. As the photographers continue to improve their skills by reading publications like *Shutterbug*, attending workshops and seminars, and practicing their art, they eventually reach the third phase.

At this level, the image that these photographers see in their camera's viewfinder is exactly the same thing that appears on their prints or slides. While reaching this phase can be fulfilling, some of the magic is gone. If you would like to experience some of the same thrill of discovery that occurred during the first phase of your photographic education, we would like to suggest that you photograph when the available light may not be so available.

The Gasp Factor

When you turn the pages of magazines, books, and newspapers do you ever notice how some images just "grab you"? These great photographs are unique; they are different. They literally force you to stop and take a second look at them. When confronted by this kind of photograph, do you sometimes wonder, "How was that taken?" Or do you simply say, "I wish I could do that"? The goal of this book is to tell you how to do both. We take you behind the scenes and show you how a number of available light photographs were made, and in the telling we hope to help you improve the photographs you make using available light.

Dick Stolley, who was by many reports the best Managing Editor at Time-Life, once told *People* magazine's Contributing Photographers that a successful photograph elicits a "Gasp Factor" from the viewer. If an image stopped the reader, forced him or her to take a second look at it, to read the story's headline, and then perhaps the rest of the story, the photograph passed Stolley's test. Often the best photographs—the "Gasp Factor" ones—are taken under less than ideal conditions. These "gasp" images are made on dark, cloudy, stormy days, at the crack of dawn, at sunset, or in the dark of the night.

Available light, unavailable light, available darkness, or low light. It doesn't matter what you call it, but the truth is that the most rewarding photographs can be produced when you are working under the most challenging lighting conditions. There are several reasons for this:

First, there is the thrill of overcoming the technical obstacles that might normally prevent you from producing a well-exposed image.

Second, photographs made under conditions different from the "F16 and the sun over your right shoulder" instruction-sheet standard have a more eye-catching look.

Third, since most photographs are made during the middle of the day, taking the time to search out other than "normal" lighting conditions, such as those that exist just after dawn or before sunset, will produce photographs that will look truly different from the rest of the pack.

The sun can be at extremely low angles to the horizon early or late in the day and produces dramatic, moody shadows and an interplay of light that is lost when it is directly overhead. Just as challenging can be the prospect of working indoors under a

combination—or lack—of different kinds of light sources. *Better Available Light Photography* is a practical guide to understanding the many different kinds of lighting challenges that you may encounter. It has also been written to provide some answers to questions about how to overcome these challenges that you may encounter while creating great-looking photographs.

This One's for You

Better Available Light Photography is written for the amateur or aspiring professional photographer who has been frustrated when trying to create useful images under less than optimum lighting conditions. If you have tried to photograph indoor sports, special events (such as plays and dance recitals), holiday lights, and fireworks, you know it can be a difficult process. If you have been frustrated by your experiences, the tips, tools, and techniques we share with you will help improve all of your available and low light photographs.

You may be surprised to learn that you already own most of the equipment for successful low light photography. In addition to camera and lenses, you will need a tripod (we'll show you how to improvise when caught without one, too), an umbrella or poncho to stay dry, plastic bags to protect the equipment, a pair of long johns for winter photography, and an adventurous spirit to try something new. As you begin your own adventures in available light photography, you will quickly discover that the rewards far outweigh the inconveniences.

Most of the images created in this book were produced with 35mm Nikon cameras. Some of those images were created using Nikon lenses and some with lenses from Sigma Corporation. Most of our medium format photographs were created using Bronica and Hasselblad cameras. Tripods are an important part of available light photography, and in the book you will find tips on picking out the right tripod for your own special applications. We both prefer Gitzo tripods and monopods, and we like to use Domke and Lightware camera bags, but beyond that—and our choice of camera brands—we have very different styles of working. That's why in certain parts of the book you will see sidebars labeled "Notes from Barry" or "Tips from Joe." In these special sections, one of us will speak directly to you and share a low light tip, tool, or experience.

The information about which camera, lens, and film was used for each photograph should be viewed as a guide to the class of equipment you will need to recreate our results. If any special equipment was required, we will tell you what it is, how we used it, and where you can find it. Appendix B lists the companies whose products are mentioned in this book along with complete contact information, including Website addresses.

Keep in mind that the brands of equipment we use are *personal* choices. You don't need to use the exact gear that we used to produce images similar to what you will see in these pages. But that does not mean our information will not work for Pentax cameras or Tenba bags or Benbo tripods—far from it. The gear that we utilize is based on our preferences, so *vive la difference* and use whatever brand of equipment you prefer.

It's All About the Photographs

After reading a few pages, it will become quickly apparent to you that this is a different kind of photography book than you may have read before. Sure, we include the kind of photographic tips, tools, and techniques that enable you to create better available light images, but there is much more. For example, almost all of the images you will see were made on assignment for commercial clients, magazines, and newspapers. While some were made for our personal use, most were made under the real-life demands of deadlines and clients in a hurry to get their work. In fact, one involved a fifteen-hour marathon shoot that ended in delivering over 32,000 color prints to the client less than four days after the images were shot!

What we have tried to do in these pages is to take you behind the scenes in this kind of assignment in order to let you "walk a mile in our boots or moccasins," if you will, to see what it is like to create images under demanding lighting conditions. We will try to let you see what it's really like to photograph the president of the United States when surrounded by a pool of photographers. We'll put you in our shoes as we walk the dark, snowy streets of a big city looking for pictures that show "the weather." We will also put you behind the viewfinder of a photographer as she takes a photograph of a welder *without* looking through the camera as the image is being taken.

The point of all these stories is to let you know that all photographic situations—especially those made under low light con-

ditions—are unique. Showing you how we solved some of those problems, often with little time to think about anything but how to get the shot quickly, gives you the benefit of our experience in standing in wet boots, with cold fingers and sometimes runny noses, to be able to get *the* shot.

This book is about the adventure of photography. It is about being passionate in creating images that reflect your view of the world—not the recreation of someone else's ideas. Our challenge to you is that you also will sometimes have to brave the elements to produce great images. Are you ready to take your camera out of its case in the rain and snow, or to get up in the middle of the night to prepare for the sunrise? Will you miss dinner for a beautiful sunset? Would you sacrifice a good night's sleep for a shot in the dark? Are you ready to try hand-holding your camera for an exposure of 1/8th or 1/4th of a second? Will you shiver with us on a cold winter's night? Are you willing to expose your film when your in-camera meter screams "Underexposed?" If you answered "Yes" to these questions, then this book is for you. In the pages that follow, we will guide you through all of the steps necessary to produce some of the most exciting images you have ever taken in your life.

Joe Farace
Barry Staver
Denver, 1998

1 Available Light

ZA

Golden Hour: n 'gol-den 'au(e)r

It is 3 A.M. as your alarm clock jolts you into semiconsciousness. It's pitch black outside; last night's storm has subsided, but it's still 5° below zero. Ten inches of fresh snow covers the countryside. No other creatures are stirring, yet you are planning on going out in this weather to make photographs. To be comfortable outside you will need to put on every warm piece of clothing you own (long johns, wool socks and heavy boots, layers of shirts and pants, gloves, perhaps a scarf, and a hat with ear flaps), brush the snow from the car, scrape the ice off its windshield, and drive fifty miles on as yet unplowed roads. When you arrive at your destination (it's still 5 below) you may have to hike to the spot you have selected, set up a tripod (it's still dark), mount the camera onto it, and wait, and wait. Wait for what?

The Golden Hour

You will be waiting for the first rays of morning light to illuminate the sky, waiting for the warm glow of dawn to flood across the landscape. What you are waiting for is called the "Golden Hour"—those precious fleeting minutes when the quality of light provides photographers with images that truly separate photographs from mere snapshots. Is the wait worth it? You'd better believe it is.

other warmly. This illustration was made as both turned and laughed at a remark they overheard.

Artificial Light

The quantity of light is necessary to determine the correct exposure; how to make that determination is covered in detail in Chapter 2. The subject of this section is the color of that light, and how to handle the many variations in natural and artificial lighting situations.

"It's too dark for that picture," or "I sure wish it was brighter," or as someone remarked in Kodak's recent commercial for its ISO 1000 speed film, "Your shot won't turn out, not enough light." These statements are not often heard outdoors in broad daylight. They are typically reserved for those back rooms and dark interiors where we struggle to capture images on film. Today's cameras and film can easily handle most daytime lighting situations with no problem. The obvious exceptions are during a full solar eclipse, or under a dark and heavy cloud-covered summer thunderstorm. By the same token, today's cameras and film, when properly chosen, can handle many indoor low light situations too.

Let's look at the challenges to successful artificial light photography. In addition to the darkness mentioned above, the type of light inside is quite different from that produced by our Sun. It has a different color temperature, and it often illuminates from different directions and angles. Do your interior images have that awful green cast to them?

Color Temperatures of Common Light Sources

Light Source	Color Temperature (K)
Skylight	12000 to 18000° K
Overcast sky	7000° K
Average daylight	5500° K
Electronic flash	5500° K
White-flame carbon arc	5000° K
500-watt, 3400 K photo lamp	3400° K
500-watt, 3200 K tungsten lamp	3200° K
200-watt light bulb	2980° K
100-watt light bulb	2900° K
75-watt light bulb	2820° K

1 Available Light

Golden Hour: n 'gol-den 'au(e)r

It is 3 A.M. as your alarm clock jolts you into semiconsciousness. It's pitch black outside; last night's storm has subsided, but it's still 5° below zero. Ten inches of fresh snow covers the countryside. No other creatures are stirring, yet you are planning on going out in this weather to make photographs. To be comfortable outside you will need to put on every warm piece of clothing you own (long johns, wool socks and heavy boots, layers of shirts and pants, gloves, perhaps a scarf, and a hat with ear flaps), brush the snow from the car, scrape the ice off its windshield, and drive fifty miles on as yet unplowed roads. When you arrive at your destination (it's still 5 below) you may have to hike to the spot you have selected, set up a tripod (it's still dark), mount the camera onto it, and wait, and wait. Wait for what?

The Golden Hour

You will be waiting for the first rays of morning light to illuminate the sky, waiting for the warm glow of dawn to flood across the landscape. What you are waiting for is called the "Golden Hour"—those precious fleeting minutes when the quality of light provides photographers with images that truly separate photographs from mere snapshots. Is the wait worth it? You'd better believe it is.

Notes from Barry:

Most sunrise and sunset images are a dime a dozen. The "Mexican Sunset" image was made in Puerto Vallarta, Mexico, while shooting an assignment for Mexicana Airlines. The company had hired me to photograph several Mexican cities to capture their atmosphere for use in future tourist promotions. The sunset session had been planned with regard to the position of the sun and the beach, and the arrival of the horseman was a welcome addition. The rider and his horses provided the vitality necessary to elevate this image from a mere everyday snapshot at the beach to an interesting and romantic image. I only had one chance to catch them as they rode by. (See Figure 1.1 in color insert.)

A sunset can happen rather quickly, so it is important to have most of your work done in advance. For example, you should already know which film and lenses you plan to use. In order to do this you should have scouted the location and determined the best spot to place your camera. These questions need to be asked: Do you have a foreground object or landmark to add interest? By doing all this planning ahead of time—before the golden hour arrives—you will be free to concentrate on metering the lighting of the scene as the sun drops (and it *does* change) and framing the image properly.

We have all marveled at the beautiful colors in the sky and snapped blindly away only to find that the photographs do not represent the kinds of images we thought were actually there. Too often in these kinds of photographs, there is no subject in the foreground, or unwanted obstacles appear that weren't observed when the film was originally exposed. (Have you ever had a telephone pole sticking up behind someone's head? Where did that come from?) Once a photographer masters the technical aspects of shooting the low angled sun, then the content of the picture must be planned in order to create a sunrise or sunset image that is brimming with interest and vitality.

When will the sun set in your photographs? In a broad sense, it depends on your locale in relation to the equator and the season of the year. Northern latitudes have very long summer days with resulting sunsets that are later—approaching midnight. The opposite occurs in winter. The sunset will be more in the southern sky during winter months, shifting north as spring and sum-

mer arrive. More exact data can come from the weather section of your local newspaper, which usually gives the precise times for the sun's rise and fall each day. The exact placement of the sun along the horizon can be determined from many sources. It is also possible to visualize the sun's setting point by watching it move during the late afternoon. You can get close by watching the horizon brighten in pre-dawn. The sunrise is harder to pinpoint this way, but it obviously gets brighter at a spot where the sun actually crests the horizon.

ZAP!

Photographing the elements can be a humbling experience. Mother Nature unleashes incredible powers, dwarfing humanity with her fury. If you have ever been caught out in a heavy cloudburst, fierce windstorm, or hailstorm, near a hurricane, in the path of a tornado, in a desert sandstorm, in a blizzard, or in a thunderstorm with deadly lightning striking around you, you know that feeling. In cases like this, there is nothing you can do except wait it out. Well, you could be taking photographs while you wait.

Weather Tip from Barry:

The elements provide the backdrop and subject matter for many incredible photographs. To capture these images a photographer must be willing to uncover his or her precious camera and risk getting it wet. Don't worry, your camera can take it. Modern cameras are well-sealed and modest rain or snowfall will not penetrate their interiors. Of course, you will need to take some precautions to cover it between exposures. Tuck the camera inside your coat. Put a plastic bag over it, or put it back inside your (hopefully) waterproof camera bag. Under these conditions, you won't melt and neither will your camera.

Most lightning shots are made from afar so that a cityscape or landscape can be included as a framing device for the composition. The distance provides safety, and the city in the foreground or background can produce a dramatic photograph. A typical summer day in Denver, Colorado begins with blue sky and warm to hot temperatures that often shift into a stormy

afternoon. Weather in the form of dark, ominous clouds often roll in from the Rocky Mountains west of the city. In less than thirty minutes, a nice day can become a dark, stormy one, followed by clearing, a beautiful sunset, and a pleasant evening. Nevertheless, you don't want to be out and exposed in a lightning storm. Lightning kills people.

The storm depicted in the illustration lasted into the evening, with strong winds, torrents of intermittent rain, and lots of lightning. There wasn't time for Barry Staver to drive out of town to shoot back at the lightning, but a photograph needs subject matter for framing and interest. A nearby park, with its pavilion surrounded by high-rise apartments and tall trees, provided a great foreground. His car proved to be both shelter and a serendipitous "tripod" to make the series of exposures that produced the illustration. To eliminate camera vibration, the car's engine had been turned off. It then became a matter of luck and a willingness to expose a lot of film in order to capture a lightning bolt onto that film at the same time that the shutter was open. Several frames had small lightning strikes off in the distance and several frames were blurred and unusable, but one hit the jackpot. It was not until the film was processed that Barry discovered the treasure. Was it worth seventy-two exposures? He thinks so.

Light is Light

It doesn't matter what subject—person, place, or thing—you are photographing, the ultimate subject of any photograph is light.

Light, whether it occurs naturally or artificially, has three basic characteristics: quality, quantity, and color. The quality of the light on a subject ultimately determines the effectiveness of your photographs. That's why we will spend lots of time taking you behind specific photo shoots to describe the conditions under which the images were made. These descriptions of the aesthetic decisions that were made are designed to help you literally "see the light" so that you can benefit from our experience, but the best way to learn how to see light is to shoot pictures and examine the success and failure of each photograph vis-á-vis the way you handled light in the final image.

If light is the main ingredient in a photograph, then the quality of the light becomes the driving force in producing successful images. To gain understanding about light, let's get some scientific stuff out of the way first. As you know, the earth's

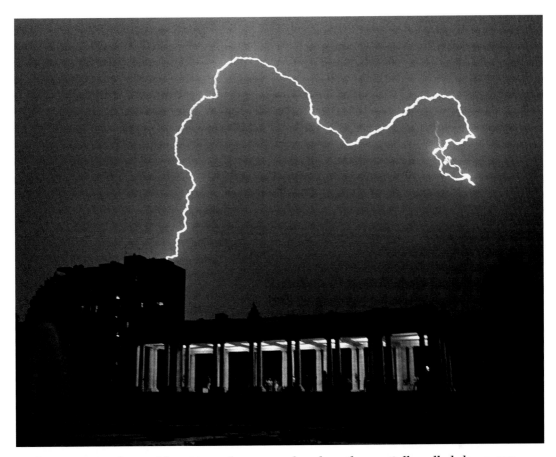

Figure 1.2 A Nikon with a 24mm lens was placed on the partially rolled down car window. Exposures were made at one- and two-second durations with a lens aperture of 5.6. Two 36-exposure rolls of Kodak Tri-X film was exposed during the storm. A close examination of the image shows the park's fountain spraying water and several people under the pavilion staying dry. Photograph © Barry Staver.

complete rotation every twenty-four hours provides us with day and night. Our planet, with its slightly tilted axis, revolves around the sun every 365 days producing not only seasons but length of day and night. That is where those long, lazy days of summer come from as well as winter's shorter days. It's also why the far northern latitudes receive almost total daylight in summer and near complete darkness in winter.

Knowledge of atmospheric conditions is essential to your understanding of light and the golden hour. Did you know that air pollution from industrial sites and automobiles, forest fires and volcanic activity, affect the quality of light? Particulates in the air produced by these sources diffuse and scatter light rays.

The haze in a Los Angeles basin sunset produces a different quality of light than the same sunset taken on a remote beach in the Hawaiian islands. Areas near Mount St. Helens and Yellowstone National Park had their sunrises and sunsets obliterated during the volcanic eruptions and massive fires, respectively. Yet photographers thousands of miles away had intense colors added to their low light experiences.

The third aspect of light deals with the color temperature emitted by our light sources and is measured in degrees on the Kelvin scale. To successfully create low light photographs, a basic understanding of the color temperature of light is also necessary. The sun on a clear day at noon measures 5500° K. On a thick overcast day, the color temperature of light rises to 6700° K, while 9000° K is what you will experience in open shade on a clear day. These higher temperatures are at the cool or blue end of the spectrum. On the lower side, however, light sources are at the warmer end of the spectrum.

Lights used by videographers or tungsten-type lights have a Kelvin temperature of 3200°. Household light bulbs are close to that color temperature and measure about 2600°. (The color effects of artificial light are covered later in this chapter.) When we photograph that special sunrise, its color temperature may be well down on the Kelvin scale, at about 1800°. As you can see, the photographic process not only demands a certain amount of light to register an image onto film or into a digital file but also an understanding of atmospheric conditions and the color temperature of light.

Tip from Joe: Who is the Kelvin Guy?

I am constantly amazed at the misinformation I hear about the Kelvin scale. On the Internet, a power company states that the "History of Kelvin temperature originally comes from the incandescent lamp." Duh? Long before Edison invented the incandescent light, Lord Kelvin, an Englishman, proposed a new temperature scale suitable for measuring low temperatures. During the nineteenth century, he suggested that an absolute zero temperature should be the basis for a new scale. His idea was to eliminate the use of negative values when measuring low temperatures using either Fahrenheit or Celsius scales. In honor of Lord Kelvin's contributions, this system is called the Kelvin scale and uses the unit "Kelvin" or sometimes just "K."

Most of us equate daylight with the proper time for making photographic exposures, and many photographic opportunities at night or late in the day are often overlooked. They shouldn't be, but even all daylight is not the same. Most people look at the "golden hour" and see the beauty of the subject, no more and no less. You will hear comments such as "The sunrise was just beautiful," or "look at the golden glow in that portrait," and maybe "what a romantic sunset." As photographers successfully working in low light, we need to know more about the nature of light so we can capture images on film that others merely glance at.

Being Prepared: Behind the Scenes

Sometimes, as in the photographs of the Mexican beach, fortuitous happenings help make a picture better. Other times, the situation is tightly controlled and you have to make the best of the situation. That was the case for photographs made at the Summit of the Eight that was held in Denver, Colorado. This international meeting brought together the leaders of Russia, Germany, Japan, Great Britain, Canada, the United States, France, Italy, and two European Commonwealth organizations for a series of meetings and special events.

Since the world's leaders were all in the same place at the same time, security was incredibly tight. The number of journalists covering the event numbered in the hundreds, and all participating countries had their own press corps in attendance. Colorado's Convention Center was transformed into a media center to accommodate the reporters, photographers, and technical staffs of the world's Fourth Estate. All of the events were planned well ahead of time, including the number of media allowed to observe, the places for those observations, and transportation to and from the events.

In order to photograph any of the proceedings, photographers had to be accredited by a recognized media outlet, pass a Secret Service clearance, and be issued credentials. The media worked with press aides who drew straws to determine who would be at what event, or portion of an event. These shooting positions had been planned weeks ahead. Platform risers were erected so that from two to five rows of photographers could be squeezed into a small area. The time of day, the sun's position, and weather forecasts were usually taken into account. Large Hollywood movie

lights were used to fill shadows of exterior "photo op" spots. Interior sites are lit with similar lights.

On arrival day, a dinner for the leaders was planned at Denver's Phipps Mansion. Photographs were permitted while the leaders arrived, and a group photo was planned for later. The location for the group portrait was to be in the gardens at the rear of the mansion. No images could be taken inside during the dinner. Since the event was held in the United States, President Clinton was the official host. Protocol required the President to be inside the mansion, walk out the front door to greet each leader upon his arrival and allow for the traditional photo opportunities associated with these meetings.

Two photo spots were set up at the mansion's entrance. A front-facing position, with a scaffold of three rows, and a "cutaway" position, with a two-tiered riser, were used off to the side. Since the entryway was in full shade with darkness approaching, two movie lights were placed to fill the shadows. The group photograph locale in back of the mansion had a very long, two-tiered riser in place and additional movie lights for illumination.

Early arrival is the key to success at these events. At twenty-minute intervals, buses ran from the downtown media headquarters to the mansion. Photographers who had been granted access to these two shooting positions then had to deal with a "first-come-first-served" rush to get to the shooting platforms. Upon arrival at the mansion grounds, a thorough security screening had to be passed. Individuals went through the metal detectors, and equipment bags were thoroughly searched. Each camera had to be actuated and flash units were tripped. You will not be surprised to learn that security personnel do not like words like "shoot" and "fire." Police dogs were used to sniff equipment bags and check for explosives.

Hours before the event took place, security officials escorted photographers to the risers and their positions were quickly staked out. Placing a tripod on the spot chosen is the best way to reserve it. After territories were marked, photographers were escorted back to a waiting area. Approximately two hours before Clinton's arrival, a security team swept the entire area and media members were escorted to the entryway to wait, and wait, and wait some more.

Finally, the dignitaries arrived and the long hours of waiting quickly changed to a few hectic moments for making photographs. Clinton and Russian President Boris Yeltsin had met on several previous occasions, and each time they greeted each

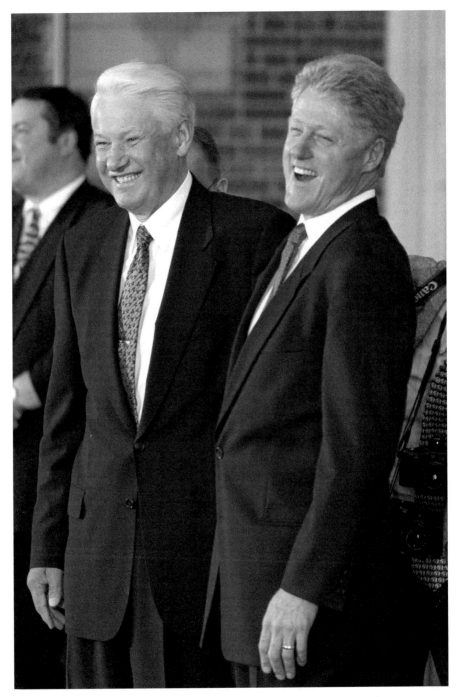

Figure 1.3 "Yeltsin & Clinton." This photograph was taken by Barry Staver on a deadline assignment for *The Denver Post*. It was made with a Nikon N90s and a 80-200 mm f.2/8 zoom. The film was Fuji 800 color negative with an exposure of 1/125 at f/4. When the greeting and group photo images were made, Barry rushed back to the bus for a ride downtown. The buses were not ready to leave, so he hitched a ride in a van carrying volunteer workers. This photograph appeared in the next morning's paper. Photograph © *The Denver Post*/Barry Staver.

other warmly. This illustration was made as both turned and laughed at a remark they overheard.

Artificial Light

The quantity of light is necessary to determine the correct exposure; how to make that determination is covered in detail in Chapter 2. The subject of this section is the color of that light, and how to handle the many variations in natural and artificial lighting situations.

"It's too dark for that picture," or "I sure wish it was brighter," or as someone remarked in Kodak's recent commercial for its ISO 1000 speed film, "Your shot won't turn out, not enough light." These statements are not often heard outdoors in broad daylight. They are typically reserved for those back rooms and dark interiors where we struggle to capture images on film. Today's cameras and film can easily handle most daytime lighting situations with no problem. The obvious exceptions are during a full solar eclipse, or under a dark and heavy cloud-covered summer thunderstorm. By the same token, today's cameras and film, when properly chosen, can handle many indoor low light situations too.

Let's look at the challenges to successful artificial light photography. In addition to the darkness mentioned above, the type of light inside is quite different from that produced by our Sun. It has a different color temperature, and it often illuminates from different directions and angles. Do your interior images have that awful green cast to them?

Color Temperatures of Common Light Sources

Light Source	Color Temperature (K)
Skylight	12000 to 18000° K
Overcast sky	7000° K
Average daylight	5500° K
Electronic flash	5500° K
White-flame carbon arc	5000° K
500-watt, 3400 K photo lamp	3400° K
500-watt, 3200 K tungsten lamp	3200° K
200-watt light bulb	2980° K
100-watt light bulb	2900° K
75-watt light bulb	2820° K

Not enough light. The meter in the camera shouts, "Whoa don't shoot here!" Perhaps your camera has red lights or annoying little beepers that warn of impending bad exposures. This is where you enter the realm of good quality high-speed films and the use of fast lenses. By combining either or both of these items along with a solid platform to brace the camera, low light photography becomes a bit more of a reality. Later chapters will deal with the specifics of fast film, fast lenses, and camera supports. Let's tackle the color balance issue first.

The preceding color temperature chart places many interior artificial light sources along its value line. You will notice that household light bulbs and tungsten lights (usually little spotlights in track lighting) fall below the Kelvin temperature of daylight. Fluorescent tubes (becoming more popular by the minute), mercury vapor, sodium vapor, and metal halide lights are not even on the chart. That's because their color temperature can vary from 1900° K up to 8000° K, depending on several factors, including the age of the bulb. Lastly, don't forget the neon signs, lasers, computer monitors, and television screens. All of these devices produce light of different color temperatures, too. What a nightmare! No wonder many of us are unhappy with or don't pursue available low light photography.

Sight, smell, hearing, taste, and touch. Which of the five senses would you not want to lose? If there is a photographer out there who does not name "sight," then they are in the wrong field and probably aren't reading this book. Our eyes see light reflected from objects and transmit the images to our brain. We "see" everything as it is. A blond person has golden yellow hair. Our redheaded friend has just that, red hair. The rancher's pasture is green (at least in summer when there is plenty of moisture) and the sky is one shade or another of blue. Bananas are, you guessed it, yellow. Oranges are, well, you get the drift. We have all come to associate certain objects with specific colors, and don't worry about unfamiliar objects either. The human eye is a marvelous organ. It interprets the colors, textures, depth, and dimension of objects and passes that information along to our brains. Our brains make sure that, whether we are outside in daylight or indoors under artificial light, bananas are yellow and oranges are orange.

Film, unlike our vision, has many more limitations. Most color film is "balanced for daylight" shooting. It renders as normal the colors seen by our eyes outdoors under daylight lighting conditions. Lacking a brain, film does not know that we have

gone inside and are now shooting under different lighting conditions. Film sees the green in those fluorescent tubes and our blond subject develops a bad hair day. Her skin turns the color of TV's *Incredible Hulk*. People sitting next to household bulbs take on a yellowish or orange cast. Our eyes see these things as "normal," but film sees these same things differently.

Here is what several typical light sources can look like on daylight balanced film.

Household incandescent bulbs (2900° K) are warm and will produce a yellow to orange cast on film.

Tungsten light sources (3200° K) are just above household bulbs and are also warm. They too produce an orange cast on film. Sometimes called quartz lights or "hot" lights, this type of illumination can be found in theater and stage productions. You'll also find them attached to camcorders and in track and accent lighting in many homes.

Fluorescent tubes (600 to 4200° K) are available in many different lengths, shapes, and color types. Their average color temperature has a wide range from warm white to daylight. Manufacturers produce many different tubes, and each tube's temperature will also change as it gets older. Most fluorescent tubes will produce a disgusting green light that you cannot see, but film certainly does.

Mercury vapor lights (4500 to 7000° K) are found in factories, warehouses, stadiums, and other large spaces in need of light. They have a lot of ultraviolet and green in them. Our eyes see these light sources as having an intense whitish-blue cast.

Sodium vapor sources (300 to 1900° K) are the ones with an ugly yellow cast with a touch of green tossed in. You will find them in parking light fixtures, some factories, and yellow street lights.

Metal halides (2000 to 8000° K) combine some characteristics of mercury and sodium vapor lights. You will find them in large refined spaces such as office building lobbies.

Neon lights (4500 to 6000° K), you may be surprised to know, are terrific. They look great on film.

Laser lights reproduce fine on film, like neon, but be careful where you point them. Keep the beam away from your eyes and your camera's lens.

Computer and television screens (5000° K and up) do not cause many color-shift problems either. The problem with monitors and TVs is flicker. Be sure to set your shutter speed below 1/30 second to avoid the flickering caused by the monitor's scanning that refreshes the screen image.

You now have a great weapon to add to your arsenal to attack available light photography. It is the knowledge of our eyesight's ability to see "normally" vs. film's inability to record non-daylight scenes "normally." The next time you are faced with an available light situation, look at the light sources. Where do they fit in the above scale? What color will the images look like on film? Will the results be satisfactory, or do you want to correct the photographs to a "normal" viewpoint? The next section discusses one way to bring off-color light sources into proper balance.

Matching Film to Light

One of the easiest things to do to guarantee accurate color is to match the color balance of your film to the color of the light source. While most color film is designed to match daylight, there are so-called "tungsten" transparency films that are designed for use under 3200° K light sources. Originally, these films were produced to be used on copy stands to copy flat artwork or products. These copy stands typically use quartz lights balanced at 3200°, so the film and light sources work together to produce good images. This makes them a perfect match for a copying situation, but these same films can be used indoors with table lamps to produce "acceptable" results. One reason that the results may not be perfect is that light bulbs are not made to produce a perfect 3200°, and as they age, they usually change color temperature and grow warmer.

Manufacturers offer many different kinds of film balanced for either daylight or tungsten lighting conditions, but nobody makes a sensitized product that easily handles a mixture of sodium vapor, tungsten, a little bit of daylight, and some of those "mystery" lights that appear to be quartz but actually photograph like fluorescent lights. Fuji's NPS color negative film is specifically designed to perform well under a wide variety of lighting conditions, as is their Super G Plus 800 color negative film.

Some photographers think that shooting a low light job on color negative film solves the problem by passing the buck and letting their lab worry about the color. The truth is that any professional lab still needs a properly balanced and exposed negative to start with. If not, problems with color crossover can occur—part of the photograph's color may look OK, but the rest may be incorrect. When shooting color negative film, the real secret of having a lab deliver great prints is to give them great negatives to start with.

If you are shooting transparencies, the only way to produce acceptable results from off-color originals is to make color-corrected reproduction-quality duplicates which can be expensive. What's left? Making excuses like "that's the way it has to be" can only lead to unhappy clients and is not an acceptable, or professional, way to handle a technical problem. In short, the best way is to get it right on the film the first time.

Color Temperature Meters

Much as you can measure the quantity of light using your camera's built-in meter or a hand-held light meter, you can also measure the color of light using a color temperature meter. The Minolta Color Meter IIIF, for example, makes readings based on one of three types of film: Daylight (balanced for 5000° K), Type A Tungsten (balanced for 3400° K) and Type B Tungsten balanced for 3200 L.) The IIIF's LCD display lets you view color temperature readings three ways. You can view the readings based on using the Light Balancing (LB) or Color Compensating (CC) indexes. Light balancing filters are those with names like 81 or 85, while CC filters are based on the actual value of the filter. The filters in the 85 series are generally called "warming" filters since they are orange in color. The filters in the 80 family are blue. Both series of filters vary in intensity of color, and this is reflected by the letter placed after their numerical designation. An 85B filter, for example, is often used to correct photographs made under tungsten illumination that are photographed using daylight film. A 30M CC filter, for example, is a magenta filter that has a CC value of thirty. The higher the number, the deeper the filter color. A color temperature meter can also display the actual color temperature of the scene in degrees Kelvin, which is useful when analyzing a situation for the first time. A third mode will display CC settings along with Kodak's Wratten filter

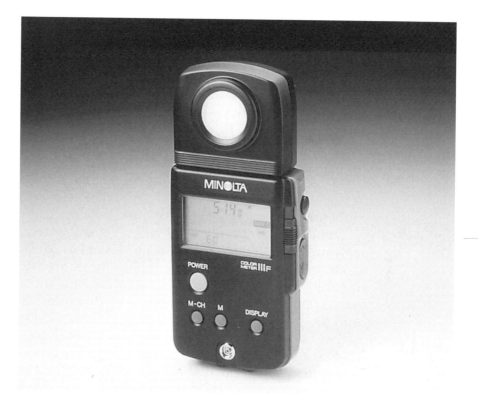

Figure 1.4 While no color meter is inexpensive, the Minolta IIIF is priced fairly and, more importantly, is easy to use. The Color Meter IIIF can read flash or ambient light or a combination of both. Photograph courtesy of Minolta Corporation.

numbers. If more than one Wratten filter is needed, the Color Meter IIIF displays both filter numbers. The IIIF's nine-channel memory lets photographers store their personal correction values for the recommended filters. Nine sets of correction values for LB and CC indexes can be stored in memory to fine-tune meter reading so that you can use previous experience to compensate for the color biases of certain film emulsion.

Stars on Ice

Have you ever looked around at the crowd in a darkened arena or stadium? When the entertainers are introduced or the action starts, you see virtually thousands of little flashes. It's a regular

light show. People are aiming their point-and-shoot or disposable cameras at the action, but most of them don't know that the range of a flash on that type of camera is perhaps ten feet—maximum! In short, the flash will not add any light to the performance area but may illuminate the shoulder of the person in front of them. Today's disposable cameras typically use 400 ISO film, so there is a slim chance the image will be slightly recognizable, even though the size of the people on stage will appear minuscule in the photograph.

To capture theater, stage, and sporting event action requires a long focal length lens and fast film. The combination of low light and moving objects compounds the difficulty in getting an acceptable photograph. This assumes, of course, that the event you want to photograph even permits photography. Many concerts and performances have union rules prohibiting any photography of the participants. Even accredited media shooters are only allowed to shoot the first one or two numbers at a concert, and the usage is limited to publication as an editorial work. No rights to advertising or commercial usage are permitted. In addition, a flash can be disruptive at many events, forcing photographers to use available light only. Skaters, basketball, and hockey players can be momentarily blinded by flash, and that is just one of the reasons that the use of electronic flash is not allowed.

The illustration showing the performance of Elena Bechke and Denis Petrov at the Stars on Ice Show was photographed on assignment for *The Denver Post* at McNichols Arena in Denver. These two skaters are Russian Pairs Champions and Olympic Silver medalists. Arrangements were made ahead of time and Barry Staver was met by a publicity member of the ice show staff. After a discussion about the show, Barry discovered the following information:

- Only the opening number, a twelve-minute performance in which all cast members had a short role, could be photographed.
- No flash was allowed at any time.
- The photographer would only be permitted to stay in one location, because the show organizers thought that his moving around might distract the audience. The publicist had kept a space open two feet from the ice in the center at the north end. The best action, fortunately, all occurred at the north end of the ice.

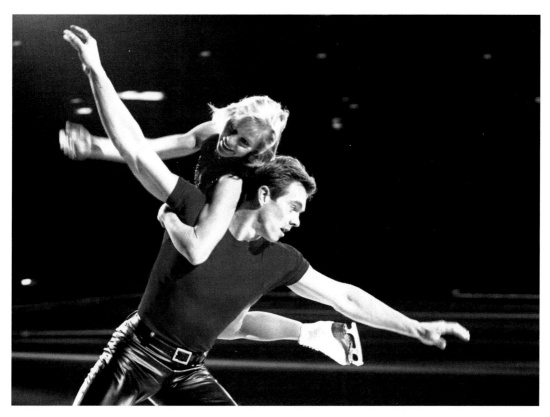

Figure 1.5 This photograph was taken with a Nikon f/2.8 80-200 zoom at 1/250 second at f/4. In-camera metering was set to center-weighted with shutter priority. By using color negative film, the imbalance of daylight film with these tungsten stage lights can be corrected in scanning or printing. Had this been shot on daylight-based slide film, the image would have had an orange cast to it, although tungsten-based slide film would have rendered the scene in the proper colors. Photograph © *The Denver Post*/Barry Staver.

• No preliminary lighting check was possible, because the show was primarily lit by spot lights and colored accent lights that vary in intensity during the show.

Twelve minutes goes by very fast when you are concentrating on following focus with ice skaters—anticipating their jumps, landings, spins, and turns—as well as camera, film, and lens changes. The assignment was shot with two Nikon N90s cameras and three lenses: 35-70mm f/2.8 zoom; 80-200 f/2.8 zoom; and a 300mm f/4. Three rolls of Fuji 800 color negative film were exposed during those twelve minutes.

> **Tip from Barry:**
>
> A 300mm lens was not long enough to photograph a single skater at center ice from the far end of the arena. I moved to the side of the rink when the house lights went down to get a tighter shot of skater Scott Hamilton. This move was done quietly and without fanfare and resulted in no cat-calls from the nearby audience members.

Mixed Light

As Andy Rooney might say "You know what drives me crazy? I'll tell 'ya what. Making photographs under mixed lighting, that's what!" This section examines an industrial shoot involving a wide variety of lighting conditions and shows how the problems were solved to the client's satisfaction.

Like most assignments, this one started with a phone call. The PR Director of the local Caterpillar dealer called Joe Farace and asked him to shoot a montage of images that would be used on the cover of their new brochure. The brochure was designed to highlight their well-equipped service facility, and all of the photographs would feature their hardware and employees under actual working conditions. Since the project involved "people" it was an assignment that normally would have been shot by his business partner and wife, Mary Farace, but since it was also somewhat technical, it was obvious that he would be involved in some of the preplanning.

On all but the simplest assignments, Joe's philosophy is to visit a job site before the shoot is scheduled. In this case, the client already knew of eleven or twelve situations he wanted to include in the montage, so the initial visit gave Mary the opportunity to see exactly what the existing light situation was like. When she went on-location, Mary made notes on where each set-up would be and possible solutions to the lighting problems To help with her interpretation of the available light data, Mary brought a Minolta light meter to measure existing light and a Minolta Color Meter to measure the color temperature.

After the site visit, Mary and Joe had a meeting to analyze the data she had collected, and the results were interesting. They started by separating the set-ups into three different types of

shooting situations. The easiest shots were those that were mostly daylight, or those that would be cropped so tightly that the color of the ambient light would not be a problem. In these set-ups, electronic flash would be used as both main and fill light. The second series of shots were found to be predominantly tungsten in nature (although not necessarily that kind of light in actuality), and they had color temperatures ranging from 2840 to 3040° K. Since the median color temperature of these set-ups was 2900°, they looked for help from the Rosco Cinegel color-correcting filter swatch book. Sure enough, they found what they were looking for: the sample marked "Roscosun CTO 3407" is designed to convert 5000° K light into 2900°. Mary and Joe decided to use these Cinegel filters over the strobe heads to match the color of the existing light, and an on-camera filter to convert all of the light in the photograph into daylight. As an average of the filtration recommended by the Minolta meter, a Kodak 80B (blue) gelatin filter would be used on the camera. If Joe needed something a little different on the strobes, he could also use the Rosco filters that convert daylight to 3200, 3800, or 4500°. (See Figure 1.6 in color insert.)

The third type of set-up involved everyone's favorite lights—fluorescent. Looking through the Rosco sample swatches, Joe and Mary found "Tough Plusgreen/Windowgreen 3304," which is a gel that adds green to natural and artificial daylight sources to balance with the ubiquitous "Cool White" fluorescent tubes. The 3304 gels were selected to be used on the strobes, along with a Kodak 30 Magenta gelatin filter on the camera. If you need less green on your lights, Rosco also offers "Tough 1/2 Plusgreen 3315," which is equivalent to a CC15 Green filter, and the "Tough 1/4 Plusgreen 3316," which is equivalent to a CC075 green filter. Are you using quartz lights instead of strobes? The Rosco "Tough Plusgreen 50 3306" converts 3200° K light sources to balance with "Cool White" fluorescent tubes. Rosco also offers a series of "Minusgreen" magenta gels that can be applied directly over the available light fluorescent source to convert it into daylight. If you find a small pocket of fluorescent tubes that are showing up green in your shot, all you need to do is tape a few sheets of "Tough Minusgreen 3308" over the light source and forget it. Mary and Joe have done just that on several assignments—especially in retail situations where fluorescent light sources are rampant. Gelling the light sources is a small step that can improve the shot while showing the client that you are willing to do a little extra for the best possible job.

> ### Tip from Joe: Rosco Color Correction Material
>
> I have found Rosco's Cinegel filter material to be indispensable for working under mixed light sources. Cinegel material is available in rolls or 24-inch square sheets and can be easily cut to size with scissors and taped with Gaffers Tape over your strobe heads. Be careful of your modeling lights. The light-bulb-style modeling lights used by Bogen and other manufacturers have not created any problems, but on another assignment, the hotter 150W quartz modeling light in another studio's lights burned a hole in a sheet of Rosco's 3304. It took a long time to clean the melted green gel material off the modeling light. If you don't already have a set of Rosco samples in your files, contact them at the address shown in the back of the book.

Make a List

Armed with the information on how to handle the color temperature of each shot, Mary prepared a 6x8-inch index card for each shot. On each card she wrote the equipment and filtration needed for each set-up, then drew a sketch of where she thought the lights should be placed. Since time would be of the essence, these cards would be used by the assistant to quickly knock down one set-up and move the equipment to the next one. All photographs on the assignment were made with a Hasselblad EL and 80mm, 60mm, and 150mm Hasselblad C lenses. A Hasselblad Professional lens shade was used on each lens, and the 75mm x 75mm (3-inch) camera gels were dropped into the filter slot. While they would normally have used transparency film for an assignment of this type, the film used was Kodak professional color negative stock. That was because the client requested prints that he would use in constructing his montage, and from these the separations would be made. The strobes used for the assignment were a combination of a pair of Bogen 800B Monolights and two Bo-Lights. Extensive use was made of Polaroid 668 film both to check the set-up and to give the client a preview of what the final shot would look like. The Polaroid shots helped show how the color-correction process was working, and they were used by the client to make a preliminary mock-up of what his final layout would look like.

Figure 1.7 Green Machine. The Component Rebuild shop is a heavily fluorescent-lit area. All strobes were set at full power and were gelled with Rosco Cinegel 3304. The main light used a 45-inch Westcott silver umbrella, and the fill has a 45-inch Westcott Optical white umbrella. A Bogen Bo-Lite used barn doors and was aimed to illuminate the transmission being tested. A gobo was held by an assistant to avoid glare on the equipment. The camera lens was filtered with a Kodak 30 M 3x3-inch gelatin filter. Photograph © Mary Farace.

The Filter Factor

One of the photographer's main weapons in the ongoing war with mixed light sources are filters. Joe Farace shot an assignment for a department store chain involving the photographing of 132 different displays in a model store. Because of the large number of set-ups that needed to be accomplished in a single

Figure 1.8 JC Penney. This photograph was made during a department "model" store assignment. Photograph was made on 35mm 200 ISO transparency film—pushed one stop to an EI of 400. Prior testing showed this particular emulsion to yield better results (finer grain and no color shift) than shooting 400 ISO film with normal processing. Camera used was Nikon FM2 with 50mm F1.4 Nikkor lens with a Tiffen 30M (screw-in) filter recommended by a Minolta Color Meter. Available light exposure was one second between fs.6 and f8, with camera on a Gitzo Studex tripod, and bracketed—in half-stop increments—one-stop on either side of camera meter's recommendation. Photograph © Joe Farace.

day, existing light had to be used instead of supplementary lighting. All of the photographs on this assignment were made on 35mm Kodak ISO 200 transparency film pushed one f-stop to an Exposure Index of 400. (For more information on film speed and exposure index, see Chapter 4.) Prior testing had showed that this particular emulsion yielded finer grain and no color shift when shot at a higher Exposure Index. Slide film was chosen because the client needed to have slides to use in a presentation, in which over 135 books containing one print from each slide would be distributed to everyone in the audience. The shoot was scheduled for Thursday, and over 32,000 prints—as well as a tray of slides—needed to be delivered Monday morning.

The variations in color temperature within a single shot were much more extreme than in Mary's industrial assignment. Consequently, Joe bracketed the recommended filtration as well as exposure. (There will be more information about the concept of bracketing later.) This ended up with Joe exposing forty-four rolls of 35mm Kodak color slide film in fifteen continuous hours of shooting.

During the fifteen-hour shoot, Mary would come to the location, pick up Joe's exposed film, and take it to be processed. She waited for the film to be processed, edited it for the best exposure and color, then took the slides to another lab that specializes in making prints from slides. While she waited there, they made test prints of each slide. She came back to the job site, presented these test prints to the client for his comments, then picked up the film Joe had shot in the interim, and started the process over again.

The bottom line for both of these assignments is that to do a job right takes time: time to visit the site and find out what kind of light you are going to have to deal with, and time to test color film emulsions and your film processing. But that does not have to means weeks—all of the above can be done in a single day. The mixed light assignment took less than seven working days from original phone call to delivery of finished prints to the client. When prior planning and testing is combined with the right tools to measure the quantity and color of the light, you will get it on the film the first time!

2 Basic Exposure Techniques

f/8 and be there

Old press photographer's adage

After all of the elaborate planning, arising in the middle of the night, and traveling to your favorite sunrise "photo op spot," how would you feel if all of the photographs were under- or overexposed and useless? Pretty bad, huh?

If you don't expose your film properly, understanding light, figuring out color balance, and visualizing the perfect shot will be a waste of time. Proper exposure begins with correctly setting the lens aperture and shutter speed in relation to each other. You can set the proper exposure yourself, manually, or let the camera do it for you. The manual method requires either a separate hand-held light meter, or you can use the one built into the camera in manual mode.

In the not-so-distant past, cameras only had a manual mode, but in the past several years, auto-exposure cameras have made significant gains in accuracy and the methods used for measuring light. New technology allows manufacturers to install computer chips in camera bodies, chips that can quickly analyze data and correctly meter even under difficult lighting scenarios. Older cameras might obtain a "center-weighted" average reading of the scene visible in the viewfinder, with Nikon and other manufacturers basing 80 percent of the reading on the center (focusing) circle in the viewfinder and the remaining 20 percent

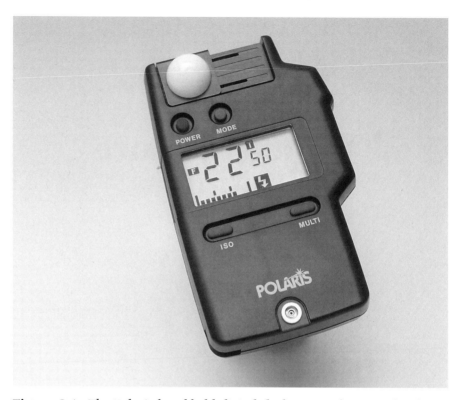

Figure 2.1 The Polaris hand-held digital flash meter also provides direct ambient—reflected or incident—readings in f/stop or EV values, saving the photographer the expense of having a separate flash meter. Photograph courtesy The Saunders Group.

on the surrounding areas. Today's sophisticated cameras can read from five to eight different areas through the viewfinder and average them together. Several manufacturer's metering systems allow the computer chip to take into account extremely high or low light areas, compensate for that area, and provide an accurate exposure.

You may wonder if you need to even own a separate hand-held meter. To those photographers who grew up with through-the-lens (TTL) light measurement, the hand-held meter may seem like an anachronism. Today, sophisticated in-camera systems have added new meaning to "TTL," but a separate meter—maybe even two—still has a special place in each of our camera bags. Like many professional photographers, we own and use several different kinds of hand-held meters. This chapter takes a look at camera meters as well as different kinds of hand-held meters and how they can help you exposure your film properly.

Light Metering

All light meters, whether they are built into your camera or separate hand-held devices, do the same thing: measure light based on a target of 18 percent gray.

Most contemporary 35mm cameras have a light meter built into them. A light sensitive element reads the amount of light entering through the lens, and either sets the camera's f/stop and shutter speed for you automatically, or provides information that lets the photographer set it manually. As long as conditions are "normal," photographs taken in this manner often come out quite nicely. As long as the illumination in a scene is fairly even, and as long as the background is not excessively bright or dark, your images will look fine. Unfortunately, low light photography does not always conform to so-called normal lighting conditions. A bright sun, a backlit window, or a very dark foreground can fool that built-in light meter and ruin your photographs.

Early pioneers in photography were not fortunate—or cursed, depending on how you look at it—enough to have access to light meters. By trial and error they devised ways of judging the illumination level in their photographs, then set their cameras for proper exposure. Often this was done by removing the lens cap—not all cameras had shutters—while these "sons of Mathew Brady" counted off seconds. Today, most people are at the opposite end of the light metering spectrum (no pun intended). Many photographic novices and, sad to say, some professionals know little about making and interpreting light meter readings, and they feel they don't have to. Somehow their camera takes care of these little problems and their pictures just seem to "turn out." That's because the sophisticated meters built into most of today's cameras sense the available light, make automatic adjustments, and result in the majority of images being well, if not, properly exposed.

Reflected vs. Incident

Light is made up of all colors in the spectrum. We see the color in objects because as the light falls upon the object, it is reflected back to us—our cameras and film. Objects are colored because they absorb portions of light. A piece of red paper is red because it reflects red light even though the white light falling on it consisted of red, blue, and green.

Metering devices sense light in two different ways. Most hand-held and in-camera meters have been designed to take a *reflected* light reading by measuring the light that is being reflected off the subject. You will not be surprised to learn that white objects reflect more light than black objects. Here is a comparison that may help you understand reflectance. In the middle of summer in the desert, would you rather wear a white shirt or a black shirt to protect you from the sun's rays? If the scene being metered by reflectance has no really bright or dark areas, the camera meter's job is easy. If something reflects a lot of light back, for example from a snow covered hill, the ocean and sand at the beach, or a shiny metal object, the meter adjusts for the extra brightness and tells the camera to let a smaller amount of light onto the film. In this situation, the typical photograph does not receive enough exposure and your images turn out darker than the original scene appeared to your eyes. On the other hand, a lot of darkness in the scene fools the meter in the opposite direction.

Early in-camera meters measured the light over the entire viewfinder and provided an average reading. Subsequent generations of in-camera meters took "center-weighted" readings that placed more emphasis on the center portion of the image in the viewfinder. The idea was that that location was where, more often than not, the subject of the photograph was located. With cameras that use center-weighted metering, it was possible to point the center of the viewing screen at the main subject, take the reading, lock it in place, recompose, then shoot your photograph.

The newest cameras are more sophisticated. They simultaneously take readings from several different places on the film plane and average them together for a more accurate exposure. Some in-camera meters claim to be able to override a very bright spot, such as a bright light bulb in the frame or a harsh reflection, to provide an accurate reading for the rest of the scene.

In-camera meters read the scene based on the focal length of the lens that you have mounted, but most hand-held meters measure an area of view of approximately thirty degrees. This is the angle of view that is covered by an 80mm lens on a 35mm camera. Some in-camera meters have a "spot" meter setting allowing them to read a smaller area in the viewfinder. (There is more information on spot meters later in this chapter.) A spot meter is basically a reflected light type of meter shaped similarly to a pistol with a small barrel; it allows the photographer to view

and meter a one-degree spot in a scene being photographed. Some companies, such as Gossen, offer spot meter attachments for their light meters that allow photographers to narrow their meter's angle of view down to five degrees. A spot meter allows you to meter a specific and quite small area in a scene that will not be affected by other larger subjects that might tend to "fool" your meter.

Joe Farace never goes anywhere without his Gossen Ultra Spot. One of the features that Joe likes about this meter is that it has calibrations allowing the user to work within Ansel Adam's Zone System of exposure. Since many photographers have heard about the Zone System but may not be familiar with how it affects exposure, we asked fine arts photographer Bill Craig to provide a basic introduction. (See sidebar.)

Sidebar: The Zone System, What Is It?

To some it is a religion, while others see it is a functional tool that can be used to gain some control over the artistic process of creating photographic images. Here are some thoughts and ideas that I have acquired over the past twenty years of working with the Zone System.

First, when developing black and white negatives, all things being equal, as developing time increases so does contrast. Second, as exposure increases so does negative density when the developing time is held constant.

So what does this mean, practically speaking? Let's look at some examples. The first example is a concrete building with half the building sitting in the bright sun while the other half is in the shadows. The best way to expose this image would be to overexpose the film to get the required amount of detail in the shadow, and underdevelop the negative so that the sunlit part is not completely blocked up—that is, clear and lacking in detail on the negative. In this case, the negative density is increased by overexposing the film and the contrast is decreased by underdeveloping the negative. The secret is to know how much to over expose and how much to underdevelop the negative. The Zone System attempts to quantify exposure increase and the development times. By providing a methodology for adjusting exposures and developing times, the zone system helps photographers create negatives that will print with a full gray scale range.

Bill Craig

A second way of measuring light is called the *incident* method, which measures the light that is falling onto the subject, not that which is reflected back from the subject. Please note this important difference in what is being measured. To take these kinds of readings, most light meters have to be converted from a reading of reflected light to a reading using the incident mode. Most often this means simply sliding a device that looks like half a white sphere in place over the meter's light sensor. Some photographers call these attachments "golf balls" because that's what they resemble.

To make an incident reading, you stand in the location you want to photograph and point the meter back toward your expected camera position. Since the meter is pointing away from the subject and directly at the camera when making an incident reading, it does not matter what kind of reflective properties the subject has. This method of metering is usually more accurate and less prone to error than a reflective light meter reading. That's one of the reasons why we think that it's a good idea to carry a separate light meter, with the capability of taking an incident meter reading, in your camera bag or on your hip. The other reason is that is can serve as back-up if your in-camera meter fails or starts acting oddly.

Today's electronic hand-held meters are lightweight and take up little space in your camera bag, but they are not a panacea. If, for example, you are seated in the shade in a football stadium and the players are in the sun, a meter held in your hand will not provide an accurate reading of the sunny field. If you are in a roped-off, overcrowded photo pool at a Presidential event, neither you nor any of your colleagues will be allowed to walk in front of the President and other dignitaries to take a light reading using a hand-held meter.

In the latter situation, there are two life-saving techniques that seem to work. Just before the dignitaries arrive, a senior member of the White House press corps is allowed to cross the ropes and take a reading for everyone, or they will hand their meter to the nearest Secret Service agent or White House staff member who will take a quick reading and call out the f/stop and shutter speed combinations to the anxious photographers. If the meter was set to 100 ISO and you are shooting a high speed tungsten film of, say, 320 ISO, you should be fast at converting those settings—before the President arrives. Often the dignitary is positioned in front of a dark blue or other dark-colored, official-looking drape. If your in-camera meter "reads" too much of the

background it can cause exposure errors. That's why most professional photographers, depending on the circumstances under which they are working, use both hand-held incident meters and in-camera reflective meters.

Tales of the Fez Merchant

This "touristy" photograph of a vendor was taken in the Fez, Morocco market. (See Figure 2.2 in color insert.) It is characterized by low light levels caused by the surrounding buildings that block natural light from the narrow streets. When you look at the image this lack of light will be apparent because a bare light bulb can be seen noticeably illuminating the center of the pile of green beans and creating a hot spot. When shooting under these kinds of conditions, you should be aware that many people in third world countries are wary of being photographed. Some have even grown accustomed to receiving money in return for posing. The people in this old Moroccan town refused to be photographed at first, until they saw the representative of the mayor's office who was accompanying Barry. In any case, it is always best to ask permission before shooting photographs in these kinds of situations. Taking the time—and breaking the mood—to ask permission will often spoil the journalistic style of capturing the moment, but with patience, the subject will soon forget your presence and go back to his normal activity.

Hot Chili Diner

As you study old portraits, some motion or blurring of the subject is often visible. Weren't those photographers capable of steadying the camera, or were their subjects hyperactive? The answer to the first question is yes, and the answer to the second is no.

Early photographers had to work with glass plates covered with emulsion that, compared to today's film, was slow. The state of the art for photographers like William Henry Jackson was images created with long exposure times. It was not unusual—even for a portrait session—to require a thirty-second exposure for the kind of images created by photographers like Mathew Brady. Try this test at home with your kids. Ask them to sit perfectly still for thirty seconds. Tell them that you don't

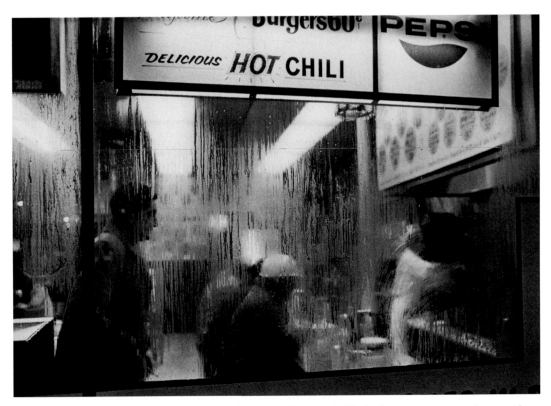

Figure 2.3 It was a dark and stormy night. This available light image was taken with a Nikon camera and 35mm lens on Kodak Tri-X film. Photograph © Barry Staver.

want to see any movement at all. You just want them to hold still. Unless we are yoga masters, it is doubtful that most of us can sit perfectly still for even ten seconds. That's one of the reasons that early portrait photographers used high-backed chairs and metal braces to hold their subject's heads in place.

For the majority of our photographs, advances in film technology have given us emulsions that don't require long exposures. We do, however, have to deal with the same basic dilemma that faced early shooters: How much light is enough? If you allow too much light to pass through your lens onto the film, the picture will be washed out. If too little light reaches the film, the picture will be underexposed and dark.

Even in non-El Niño years, the weather is news and newspaper photographers are often sent out to make images of "the weather." The photograph of the diner with steamed windows

was taken during a frigid January night in Colorado. Outside the diner, the temperature was well below zero. It was so cold that few people ventured out that night and finding a suitable weather image was difficult for the photographer. Driving around the normally busy city streets and well-lit parks provided no signs of life that would make a good cold weather photograph. After a four-hour search, Barry spotted this diner in the same block as the newspaper office. Because of the evenness of the illumination, the scene was easy to meter through the camera's lens. After making four or five exposures, the men seated at the counter stood up to leave, the cook saw the photographer, and the moment was over. If the photographer had taken the time to set up a tripod or gone inside to take a hand-held meter reading, the picture would have been lost. In this case, the camera's built-in meter did a great job.

Range Rovers

Dramatic effects can occur when you include lights that already exist in a scene into your photographs. It's obvious that lights on a Christmas tree or a house add sparkle and brilliant illumination to an otherwise ordinary image of a tree or a building. Don't forget to see lights that may exist in ordinary scenes as well. A reading lamp, track lighting, floor lamps, even the TV or computer screen, or other interior illumination can add contrast, depth, and more interest to the shot. Turning on additional lights within a room will give an otherwise plain image a real boost. Including a reading lamp with the person who is using it for illumination also adds a reality factor to the shot by showing where the light is coming from.

Exterior scenes can benefit from lights within the scene, too. A street light, the glow from the barrel of a semi-automatic during a drive-by, storefront lighting, interior lights shining out through windows all give extra sparkle to the photograph.

However, be sure that the technical and/or aesthetic quality of your shot isn't adversely affected. On the technical side, careful metering should keep the light sources in the shot from overpowering the exposure, causing underexposed film. Aesthetically, keeping the lights from overpowering your subject will insure their inclusion as accent items only. A light prominent in the foreground will draw attention away from your subject very quickly.

extra frames. You don't want to have a properly exposed but blurry bracket frame! Of course, that can be a problem when the subject is moving. Still-lifes and landscapes, however, are good places to bracket, but most fast-changing situations do not allow for the luxury of bracketing. In Chapter 5, we will introduce you to the "clip test" lab procedure that will give you the advantage of bracketing without actually doing it when you are shooting.

Barry Staver's assignment for *People* magazine was to follow a Utah veterinarian as he traveled across the Navajo reservation in New Mexico reintroducing an all but extinct breed of sheep to the women of the tribe. These sheep had wool that made for superior weaving of beautiful Navajo rugs. The Navajo people welcomed the sheep, the wool, and the veterinarian, but not the shooter. The only reason this woman allowed the photographer into her home was because he was traveling with the vet. Since this woman spoke no English, a translator was needed. The loom is the central fixture in her home, which had no electricity or running water. The scene was illuminated by light coming from a window behind the camera and the one on the left. Since the majority of the scene of the Navajo weaver is the same brightness, it easily meters using the camera's built-in meter. If the window at left had been larger or more prominent, it would have misled the camera's meter by telling the camera that there was more light than there really was, which would have caused the image to be underexposed. One way to ensure that a bright or dark object does not fool your camera's meter is to point the camera away from that object while the light reading is taken, save that exposure using whatever meter-lock system the camera has, and reframe the photograph. Out of respect for the weaver, Barry made only a few exposures then left.

Luck? Huck Finn

How often has someone said to you, "What a lucky shot," or "You got lucky on that one," or "You're so lucky." In reality, most people—especially photographers—have to make their own luck. Those photographers who are in the right place at the right time make their own luck by taking advantage of the situation in which they find themselves.

Let us give you a few examples. A photographer who camps out for three days in the wilderness to get the perfect sunset is not lucky. Perseverance positioned him or her to take advantage

was taken during a frigid January night in Colorado. Outside the diner, the temperature was well below zero. It was so cold that few people ventured out that night and finding a suitable weather image was difficult for the photographer. Driving around the normally busy city streets and well-lit parks provided no signs of life that would make a good cold weather photograph. After a four-hour search, Barry spotted this diner in the same block as the newspaper office. Because of the evenness of the illumination, the scene was easy to meter through the camera's lens. After making four or five exposures, the men seated at the counter stood up to leave, the cook saw the photographer, and the moment was over. If the photographer had taken the time to set up a tripod or gone inside to take a hand-held meter reading, the picture would have been lost. In this case, the camera's built-in meter did a great job.

Range Rovers

Dramatic effects can occur when you include lights that already exist in a scene into your photographs. It's obvious that lights on a Christmas tree or a house add sparkle and brilliant illumination to an otherwise ordinary image of a tree or a building. Don't forget to see lights that may exist in ordinary scenes as well. A reading lamp, track lighting, floor lamps, even the TV or computer screen, or other interior illumination can add contrast, depth, and more interest to the shot. Turning on additional lights within a room will give an otherwise plain image a real boost. Including a reading lamp with the person who is using it for illumination also adds a reality factor to the shot by showing where the light is coming from.

Exterior scenes can benefit from lights within the scene, too. A street light, the glow from the barrel of a semi-automatic during a drive-by, storefront lighting, interior lights shining out through windows all give extra sparkle to the photograph.

However, be sure that the technical and/or aesthetic quality of your shot isn't adversely affected. On the technical side, careful metering should keep the light sources in the shot from overpowering the exposure, causing underexposed film. Aesthetically, keeping the lights from overpowering your subject will insure their inclusion as accent items only. A light prominent in the foreground will draw attention away from your subject very quickly.

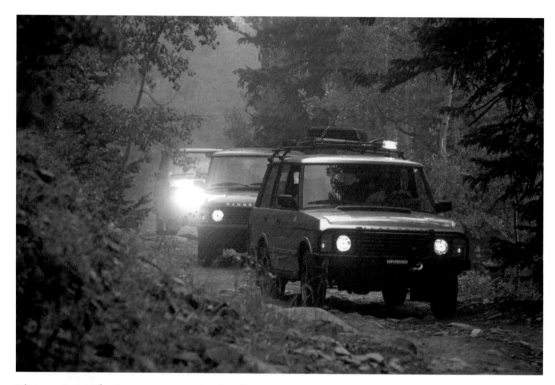

Figure 2.4 The Range Rovers in the illustration were on a 1000+ mile trek over all the high mountain passes in Colorado. The ascent up Hermit Pass was fog enshrouded. Had it not been for the mist and low cloud cover, the headlights wouldn't have been turned on, and the photograph never taken. The lights provide drama and depth to the scene and make it look more adventurous and interesting. Photograph © Barry Staver.

Respect Your Subjects

Another way to ensure correct exposure is to bracket your shots. This procedure means that you take several photographs of the same scene, changing your exposure setting each time you expose another frame of film. A typical bracket might include shooting one stop overexposed and one stop underexposed. Some photographers perform the over-under bracketing in 1/3 f/stops. After the "correct" metered reading has been shot, they shoot -1/3, -2/3, and -1 stop. Then they go the other way, +1/3, +2/3, and +1 full stop. Joe Farace prefers to use a "biased bracket" system in which you use the "computer" built into the top of your head (i.e., your brain) to determine that the correct exposure will be either over or under the stated meter's reading. That way he

Figure 2.5 The Navajo weaver photograph was taken with a Nikon, 24mm lens, on Kodak Tri-X black and white film. Bracketing was not used here because it would have taken additional time and the weaver was uncomfortable with strangers in her home. Photograph © Barry Staver.

saves film and tends to get more usable images from a smaller number of bracketed frames.

Many new cameras offer built-in bracketing, and Nikon offers an optional MF-26 camera back for the N90s that provides many functions, including programmed bracketing. One push of the shutter results in several exposures in rapid sequence. Joe will remind you that even though he owns and uses an MF-26 on his camera, the back will not do a biased bracket. So much for technology. When doing an auto-bracket using the camera's built-in capabilities, remember to hold the camera still for those

extra frames. You don't want to have a properly exposed but blurry bracket frame! Of course, that can be a problem when the subject is moving. Still-lifes and landscapes, however, are good places to bracket, but most fast-changing situations do not allow for the luxury of bracketing. In Chapter 5, we will introduce you to the "clip test" lab procedure that will give you the advantage of bracketing without actually doing it when you are shooting.

Barry Staver's assignment for *People* magazine was to follow a Utah veterinarian as he traveled across the Navajo reservation in New Mexico reintroducing an all but extinct breed of sheep to the women of the tribe. These sheep had wool that made for superior weaving of beautiful Navajo rugs. The Navajo people welcomed the sheep, the wool, and the veterinarian, but not the shooter. The only reason this woman allowed the photographer into her home was because he was traveling with the vet. Since this woman spoke no English, a translator was needed. The loom is the central fixture in her home, which had no electricity or running water. The scene was illuminated by light coming from a window behind the camera and the one on the left. Since the majority of the scene of the Navajo weaver is the same brightness, it easily meters using the camera's built-in meter. If the window at left had been larger or more prominent, it would have misled the camera's meter by telling the camera that there was more light than there really was, which would have caused the image to be underexposed. One way to ensure that a bright or dark object does not fool your camera's meter is to point the camera away from that object while the light reading is taken, save that exposure using whatever meter-lock system the camera has, and reframe the photograph. Out of respect for the weaver, Barry made only a few exposures then left.

Luck? Huck Finn

How often has someone said to you, "What a lucky shot," or "You got lucky on that one," or "You're so lucky." In reality, most people—especially photographers—have to make their own luck. Those photographers who are in the right place at the right time make their own luck by taking advantage of the situation in which they find themselves.

Let us give you a few examples. A photographer who camps out for three days in the wilderness to get the perfect sunset is not lucky. Perseverance positioned him or her to take advantage

Figure 2.6 Huck Finn on the Mississippi. A Nikon camera was used with an 85mm lens and Kodak Tri-X film. Photograph © Barry Staver.

of the good light that eventually appeared. Was Bob Jackson's Pulitzer-prize-winning photograph of Jack Ruby shooting Lee Harvey Oswald purely luck? Some have argued just that, but Bob was in the right place at the right time, and he had his camera up and ready. In this situation, he made his own luck.

The Dallas *Times Herald* assigned two photographers to cover Oswald's departure from the police station where he was being held. The first photographer was stationed in front of the police station where prisoners were normally brought out. Jackson was relegated to an out-of-the-way, seldom-used entrance, and the Dallas police decided to take Oswald out through the little used underground entrance. The loud report from Ruby's pistol shot startled Jackson and caused him to trip the shutter on his camera. Other photographers near him did not get the same picture. He did not even know what was on his film until it was processed later and he held the negatives up to the light. Lucky? Bob Jackson made his own luck that day. He stayed at his

assigned spot, had his camera loaded, flash turned on, and had the camera up to his eye, ready to shoot.

The Hick Finn photograph was done on assignment for *People* magazine to commemorate the 150th anniversary of Mark Twain's classic novel. For Barry Staver it was both a dream assignment and a nightmare. Imagine a picture editor telling you to recreate a few scenes from *Huckleberry Finn* as though you were traveling down the Mississippi River with Huck 150 years ago. You have ten days to complete the job, and if you can't get the photographs to work out, it's not a problem—it was a crazy idea anyway.

Despite unusually cold February weather and heavy overcast skies, the final image proved to be quite successful. This photograph was taken on the ninth day of the trip, with the first eight days going into planning, scouting locations, hiring carpenters to build the raft, searching antique shops for the props, scouring the Baton Rouge, Louisiana area for Huck and Jim models, and transporting the materials and people to this location at river's edge. After nine days of overcast drizzly skies, a small hole opened in the sky for just ten minutes. It provided the highlights across the water at the left and added the sparkle necessary to turn this snapshot into a portfolio image.

Under these conditions, bracketing was not possible, but experience told Barry that the sun's reflection on water would throw a light meter off and would cause the film to be underexposed. Too much underexposure would have caused the near side of the raft to go completely black with no detail. The lens was opened up one stop from the meter's recommended setting to prevent underexposure. Making this decision caused the highlights on the water to wash out a bit, but it did not ruin the overall effect of the photograph.

Peaches?

There is nothing more mouth-watering and refreshing than a succulent, tree-ripened peach eaten under the shade of the tree from which it was picked in late summer. The next best thing is to bring back a photograph of those peaches as a reminder during the off-season. An image like this can't be just any old snapshot. It needs to be a photograph that is so realistic that your mouth starts to water at the mere sight of the fruit. That reaction won't occur if the photograph is taken under flat lighting condi-

tions. It also will not happen if the peach is captured in the harsh noontime-bright sun.

This inviting basket of peaches was photographed on Colorado's western slope. (See Figure 2.7 in color insert.) The town of Palisade is surrounded by fruit orchards, and it was an easy task to ask a grower for permission to photograph the picking operation one summer afternoon. Several photographs were taken as workers, wearing aprons with huge pockets, worked their way through the trees, scurrying up wooden ladders to pick the ripe fruit. The sorting conveyors provided Barry Staver with images showing the mechanical side of fruit harvesting, but the photograph of the day appeared near dusk as the sun's rays streamed through the trees illuminating a few peaches in one of the bushel baskets. There was just time for a few exposures at best before the light was gone.

The situation could have been successfully metered in two ways. First, a hand-held incident meter could have been placed in the sun atop the peaches and pointed toward the setting sun. Second, the in-camera meter could have been used. To use it correctly in this situation, you would have to take into account the bright center of the photograph and the darkened perimeter. The in-camera meter must be set for center or spot metering, or you would have to bring the camera close to the sunlit fruit, set the light reading, lock it in, back up, recompose, and shoot. Are you hungry yet?

On the Spot

There are times when you find yourself under extreme lighting conditions, such as at the beach or on a snow-covered hill. These are the kinds of situations where a spot meter can be a useful tool. A spot meter reads light off a very small area at a distance, similar to a scope on a high-powered rifle. A spot meter's one degree of coverage allows you to place the "spot" in the viewfinder exactly where you want to measure only the subject— not the surrounding area. These kinds of meters are also helpful in metering a scene that has extremes in lighting.

This photograph of comedian Jake Johannsen was made by Barry Staver at the Boulder Theater in Boulder, Colorado, during the taping of an HBO television special. Despite arriving two hours before the show's curtain call, the lighting had not been set (show biz talk for "not ready") and technicians were still

Figure 2.8 Comedian Jake Johannsen. Photograph taken with a 300mm f/2.8 lens on a Nikon camera. Film was Kodak ISO 320 tungsten, a great slide film for use under stage lighting, since it is color-balanced for the 3200° K lights. Photograph © Barry Staver.

making adjustments to lighting, backdrop, and other props. It was chaotic, and the needs of a still photographer in the midst of a major television project rank at the lowest possible point on the totem pole.

Before the beginning of the show, it was not possible to take a hand-held incident meter reading that would take into account the final lighting set-up. Once the show began there were only two shooting positions that would be available to Barry. One was off to the side and the other was half-way back in the audience area. These locations kept the photographer out of the range of the television cameras, but they also kept him from getting a meter reading from the front of the stage. Using the in-camera meter reading would be wrong, since the backdrop for this show was a very dark blue and the subject was bathed in much brighter light. The view through the camera, with a 300mm lens attached, showed the comedian from the knees up to a spot approximately three feet above his head. This was a perfect situation for a spot meter to save the day. From the location in the middle of the theater, Barry was able to use a Pentax spot meter to obtain a reflected reading off the comedian's face.

In a Twinkle

Any scene with extreme brightness or darkness gives light meters fits. The resulting images also drive photographers crazy. A nighttime scene with holiday lighting is a perfect example of such a situation. The human eye easily adapts to the colorful lights hung on buildings, trees, and holiday characters, but the camera, lens, and film combination are not as adaptive. Since the lights are the most prominent aspect of the photograph, the meter will generally read the dark area and instruct the camera to expose for a lack of light. The resulting image will be overexposed and the brightly colored lights will be "blown out," lacking all detail. There are several methods that can be used to overcome this problem.

First, take a meter reading from an area that is well lit by the holiday lights. To do this, move in close to the scene and meter it, locking the reading into an automatic exposure camera, or choosing a manual exposure setting. All you have to do is back up to your shooting position and click the shutter.

Second, you can put a longer lens on the camera and take a reading from your shooting position. This accomplishes the same thing as the first option without having to physically move in close—which is not always possible.

A third method involves exposing more film than originally planned by bracketing several different exposures of the same

scene. After shooting the exposure suggested by the camera, several more are done for insurance. Either adjust the shutter speed or the aperture to under- and overexpose the next frames of film. After the film is processed, you select the best image.

Denver's City and County Building has traditionally been illuminated at Christmas with a striking lighting display. Due to the size of the building, most photographs of the building are taken from a distance. The city even sponsors a designated "Photo Night" when the street is blocked from traffic allowing for a view unobstructed by car lights. The photograph shown in these pages was taken from a ledge outside the window on the upper floor of the building. (See Figure 2.9 in color insert.) Special permission was required in advance to make this photograph. An escort needed to accompany Barry Staver to the ledge and remain with him for the duration of the shoot.

3 Fast Lenses

A fast lens: photographic slang for a lens with a wide maximum opening.

Barry Staver

Just as in sports cars, fast is nice. It's much easier to take photographs in low light with an f/2.8 lens than with an f/5.6 lens.

An understanding of the relationship of shutter speed to lens aperture is necessary to understand the importance of lens speed. The camera's shutter speeds are measured in seconds or fractions of seconds. An exposure can be four seconds long or one second. It can also be 1/30th of a second or 1/500th of a second. This number or fraction is the length of time the camera's shutter stays open during the exposure. It's the amount of time that light passes the shutter curtain or shutter blades and exposes the film. The aperture is the size of the opening in the lens controlling the amount of light getting through to the film. You can think of these two factors as a water pipe. The aperture is the diameter of the pipe, while shutter speed determines how long a valve is open to allow water to flow through that pipe.

The amount of light getting through and the amount of time the light is allowed through are equally important to proper exposure and thus well-exposed photographs. These two items work very closely together and must work hand in hand for proper exposure control. The best part of the system is that they work in a one-to-one relationship. If you adjust the shutter by one full speed, then you must adjust the lens aperture one full stop, or vice versa.

Notes from Barry: One-to-one of What?

Lenses use the following aperture numbers:

f/2 f/2.8 f/4 f/5.6 f/8 f/11 f/16 f/22

 Two adjacent numbers in this series of aperture numbers have the ratio of approximately the square root of two.

 Camera shutters use the following speeds:

1/1000 1/500 1/250 1/125 1/60 1/30 1/15 1/4

 Shutter speeds are usually measured in fractions of seconds, with the standard sequence having an approximately 1:2 ratio between each choice of speeds. The difference between two adjacent shutter speeds or aperture values is often called a "stop" or sometimes a "full stop." Most modern cameras allow you to adjust these controls in increments of one-half or one-third stops.

 If the correct exposure is 1/1000th second at f/2, then changing the shutter speed to 1/500th second requires an aperture change to f/2.8. A shutter change to 1/250th requires an additional aperture change to f/4, and so on. If you change the shutter one speed, then change the aperture one full stop.

 Some photographers and (mostly European) equipment manufacturers sometimes talk about Exposure Values. EVs make up a numbering system that refers to *combinations* of lens aperture and shutter speed that all correspond to the same final exposure. When an exposure value is combined with a specific ISO film speed, EV numbers can be used to indicate the overall brightness of an scene, and you will sometimes hear light meter manufacturers, such as Polaris, state their light sensitivity by a having a specification of a range of EV -4 to 26 with ISO 100 speed film.

Film at Eleven

 Suppose your assignment is to photograph a subject in a low light situation. Perhaps you are indoors at a speech in an auditorium or at a basketball game in a gym. Your eye may perceive either place as adequately lit, but as a photographer you know that it's a low light situation for a still camera and film. Videographers shoot under these less than ideal conditions with no problem. The resolution at which they record is so low that even

poor light will record images onto videotape. Because of how our images are viewed compared to video, we film shooters need more light, more exposure time, or faster lenses to create the images under similar lighting conditions.

It is possible to meter the low light scene and just choose a longer shutter speed for proper exposure. After all, the pioneers in the field did this. Remember them? Their photographs of people show stoic, stiff, nonmoving folks. Do you recall the blur that resulted from people who couldn't sit still? A shot of a runner was not possible, nor one of an animated speaker. You can't rely on shutter speed alone in low light situations to capture the action of a ball game or the gesturing of the speaker. We must be able to "open the lens up" to a wider aperture, too. If we can open the lens, we can use a faster shutter speed.

Lenses are designed to work under normal lighting conditions. In photographic terms, "normal" means outdoors. Normal may be workable in overcast weather and sometimes in a brightly lit room (for example, one with skylights or large and plentiful windows). Basic lenses have apertures ranging from f/2.8 to f/4 and some even have f/5.6 as their maximum opening. On top of that, many of today's zoom lenses have a floating maximum f/stop. Check your own lenses and see if that is the case with any of yours. As you zoom to the telephoto end, the maximum f/stop gets slower—the number gets bigger. An example might be a 28-105mm zoom f/3.5-5.6. At the wide angle end, this is a f/3.5 lens, but when you get to 105mm, it is a f/5.6 lens. In an environment of unpredictable exchange rates and rising products costs, these multiple aperture lenses are designed to keep the costs as low as possible. Most moderately priced telephoto lenses above 200 mm are slow, having maximum openings of f/3.5, f/4, f/5.6, and even f/8. This allows manufacturers to produce them in a compact size and at a reasonable price.

These smaller (slower) f/stops, however, won't allow you to stop motion in low light. To stop basketball action, for example, you need to use at least a 1/250th-second shutter speed. Under these kinds of poor lighting conditions, even with high speed film (which will be discussed in the next chapter), a 1/250th shutter speed typically meters at f/2.8. An f/4 or f/5.6 lens is simply not fast enough to successfully stop sports action in low light.

If your money belt has deep pockets, a solution is available. Fast lenses are made for most major camera brands, and zoom lenses with fixed, maximum f/stops are also obtainable. Several lens manufacturers produce 20-35mm, 35-70mm, and 80-200mm

Figure 3.1 Nikon's AF Zoom Micro-Nikkor ED 70-180mm lens uses multiple maximum apertures. At one end of the zoom range, the maximum aperture is f/4.5, while at the other it is f/5.6. Photograph courtesy Nikon USA.

zoom lenses with a fixed f/2.8 maximum opening. Telephoto lenses can also be fast and need to be for sports and nature photography. For example, 300mm and 400mm focal length lenses are available with an f/2.8 maximum opening, with Canon offering (at the time of this writing) a 200mm f/1.8 lens. If you check out ad-filled publications like *Shutterbug*, you will even find a 600mm f/4 lens offered for sale. While expensive, these are the basic lenses for sports photographers and publications that need their photographers to shoot indoors or under low light conditions. The bad news: As we write this, these kinds of lenses range in cost from $1400 for the 80-200 mm f/2.8 to over $13,000 for the 600mm f/4s. (These retail prices were current when we finished the book, and they may have changed due to any fluctuations in the dollar/yen exchange rate.)

The Equipment Blues

Buying photographic equipment can be traumatic. We can't work without it, we always need to have back-ups, and the stuff is expensive. What's worse is that we are, as a group, technology

junkies. Photographers go crazy when they think about buying a new piece of equipment. The mere thought of a new fast lens is enough to drive an otherwise sane person "up a wall." The camera and lens manufacturers don't help much. Fueled by the same revolution sweeping the field of microcomputers, the photo equipment marketplace has become extremely volatile. It seems that each week brings yet another announcement of a new high-tech camera, a high-speed, lightweight super-telephoto lens, or a miniature 2400-watt second power pack. Our reaction to all of these pronouncements is predictable: we want each one!

Joe Farace has always wondered why professional carpenters are not more like us in their feelings for their tools. Like us, they need expensive tools to accomplish their work, too, and cameras and lenses are nothing more than the "tools or our trade." Yet while cabinetmakers may covet a new saw, they usually don't rush out and buy one unless they can actually put it to work. That does not seem to be the case with photographers. We are more prone to acquire an item for the prestige of owning an interesting piece of hardware. Maybe carpenters would be more like us if they could hang an orbital sander around their necks.

One of the biggest mistakes many of us make when purchasing new equipment is doing so in anticipation of getting an assignment. Does this sound familiar? The phone rings and a client you have been after for a long time is on the line. They have a big job coming up, and want to know if you can handle it? "Sure," you say, all the while realizing that you do not have the right equipment to do the best possible job. You ask if you can call back with a price quote, you sit down and price the job according to your rate sheet, schedule of costs, and studio policies. Now's the time to see what impact the cost of the new equipment will have. Oh, no! Where will that money come from? Your bottom line, that's where.

If you can cover most of the new equipment and manage to make a profit on the job, you may want to go for it, but only after the assignment is guaranteed. The way the scenario usually concludes is that our eager photographer runs out, slaps the new gear on his plastic, and the job is given to someone with a lower bid. If this sounds familiar, you know what happens next. The new hardware ends up sitting in a corner or becoming the world's most expensive bookend.

It pays to look at alternatives to purchasing new equipment. Have you thought about rentals? Rental photographic equipment tends not to be as clean as your own personal gear and occa-

sionally will fail on the job. It happened to Joe, but haven't you had your own equipment fall apart while on assignment too? Rentals do offer significant cost savings. If you have not gotten around to buying a color temperature meter, you can often rent a new Minolta Color Meter for under $25 a day. Not only that, most professional photographers can usually bill a client for equipment rentals that are related to a specific assignment. If you are not familiar with the photo rental equipment companies in your town, take a look around. It may just be a camera store that hopes you like the hardware so much you will eventually buy it.

Another good source for equipment bargains is dealers that specialize in the sale of used equipment. Buying from them always saves money over the purchase of a brand new piece of the same equipment. Burt Payne, the retired owner of a used photographic equipment store in Edgewater, Colorado, is also a Master Carpenter, so I asked him what he thought of the differences between professional photographers and professional carpenters. He thought one of the major differences was that "carpenters always buy the best equipment they can, and don't buy junk. Some professional carpenters take a lot of pride in their equipment and buy the best they can. Others will buy poor quality tools, and they're the ones that are generally looking for jobs. I feel that professional photographers are like that too."

If you have made a bad purchase decision in the past, don't be afraid to trade or sell equipment you do not need for hardware you do need. If you would rather not trade your old hardware, try to sell it directly. Instead of advertising in the newspaper, post a "For Sale" note at your lab. That's Joe Farace's first choice for selling hardware that's gathering dust for him. A note at the lab is cheaper than the classifieds, and you get a more knowledgeable buyer. Joe has even made a new friend this way. There are a lot of different ways to acquire the tools you need to do your job and get rid of the stuff you don't need. You have to be as creative in assembling your photographic system as you are in creating a photograph! If there is a moral to this story it is this: Don't let your equipment own you.

The Gymnast

Indoor sporting events cry out for fast telephoto lenses. In these poorly illuminated settings, a photographer must be able to capture the action. Magazine and newspaper editors don't want to

hear your excuses about the awful lighting at an event or the access restrictions of a sport—they just expect great images. (They've already heard all the excuses, so you probably won't be able to come up with a new one.) Under these kinds of lighting conditions, a fast lens will allow you to shoot at higher shutter speeds than with a slow lens. A telephoto lens allows better coverage of individuals at indoor sports events than a shorter lens. Fast wide angle and normal range lenses belong in the arena as well, but it is the telephoto that truly brings the action "up close and personal."

The Women's World Trials Gymnastics event is a stepping stone to the Olympic Games. It is intense, full of energy, and, as most sports are, completely controlled by television. A week-long assignment for *Sports Illustrated* was covered by two photographers. After Barry Staver had gotten the lay of the land, shot lighting test rolls and had them processed, a staff photographer from New York joined him at mid-week.

The gymnasts had the week to prepare for two weekend days of televised finals. During the preparation time, photographers had complete access to the arena on the University of Utah campus in Salt Lake City. When shooting any kind of sporting event, it is important, of course, to understand the sport and be respectful of the contestants. It only takes one ignorant photographer to lose access privileges for all of us because they interfered with a performer, caused an injury, or in general caused a gymnast to falter. By shooting the entire week, a photographer who takes the time and pays attention will get to know the security people, coaches, and contestants, and they will get to know him or her. If you are good at interacting with the participants, you will be able to establish a good rapport between photographer and those people being photographed. (See Figure 3.2 in color insert.)

On Saturday, however, the mood changed abruptly. No still photographers were allowed onto the arena floor because they would be in the background for television camera shots. Security officials became vigilant with enforcement and curt in their manner. You may be wondering that if it's a public building and a public event where authorized media representatives had been granted access all week long, what's the problem? The network paid a lot of money to the gymnastics federation and had purchased the rights to televise the event. They had also paid for the competitors' airfare, hotel, and meals during the week so that they would perform on their television network. When all was said and done, they owned the place, "lock, stock, and barrel."

When it came time to make images during the event, all of Barry's carefully chosen camera angles were gone. Any photographs he made would have to be taken from the seating area. Perhaps one of the most important skills any photographer can possess is the ability to be flexible and open-minded. The ability to change course midstream will allow you to get images when others don't. In this situation, Barry's knowledge of the sport and his preliminary work of observing the contestants all week was put to better use as new angles had to be found for taking the photographs.

Low Light Check List

Nikon, Canon, and other manufacturers would like all of us to own all of their 300mm and 400mm f/2.8 lenses. They would even love to have each of us own a 600mm f/4 lens. Yeah, right! The good news is that you do not need to spend all of your "beer money" on fast lenses.

Can you get good photographs in low light without an f/2.8 lens? Many times, the answer is yes. With the fast films available today, camera supports (see Chapter 6), and a few tricks of the trade, good photographs can be taken in low light with slower lenses. Ingenuity, common sense, and the following checklist will improve the quality of your low light sports images.

- Make sure all of the lights in the facility where you are working are turned on and turned up all the way. More and more lights are controlled by rheostats and not simply with on/off switches. Turn these light all the way up, too. Sometimes these dimmers are hidden behind drapes or panels, so don't be afraid to ask to find a building engineer who can find the lights and put them at maximum settings. Also, don't be afraid to do a little snooping around yourself.

- If possible re-aim (and adjust) any lights, that you can get access to, in the direction of your subject. For example, track lights can be rotated to point directly at your subject. When handling lights be careful. They can get very hot. Using gloves will eliminate painful burns and blisters. Joe uses the same gloves he keeps in his camera bag when shooting out of doors during inclement weather.

- Is there a reflective surface available that can be used to add fill light? Although not always possible, placing the subject near a

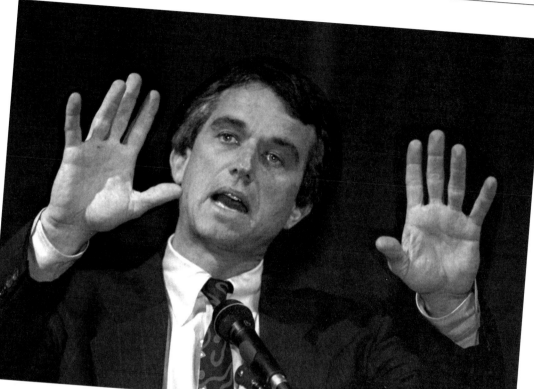

Figure 3.3 For this photograph of Robert F. Kennedy, Jr., the camera was mounted on a monopod. A small flash was used, set at two stops below normal, to fill in the shadows under the eyes. Film was Fuji 800 ISO film rated at an Exposure Index of 1600. Exposure was 1/60 second at f/4. Photograph © *The Denver Post*/Barry Staver.

white or bright wall is better than having them stand or sit in the center of a room. It never hurts to look around or ask. This trick only works with white or neutral-colored walls. Bright red or green walls can add unwanted color to your portrait subject's face.

- A shoe-mount electronic flash unit—held off-camera with a long cord—can add just a touch of extra light to fill in those shadow areas under eyes that are created by harsh overhead lights.

The photograph of Robert F. Kennedy, Jr. was taken during a speech he made on a college campus in Denver, Colorado. The room had two weak spotlights that were aimed haphazardly at the stage. Arriving early for the assignment provided time for Barry Staver to find the building electrician and get his help in

free processing for tests where each frame of the film contains a Macbeth Color Checker or similar test target. When used for these free tests, Joe's Macbeth Color Checker has paid for itself many times over.

Flash on Location

When Joe Farace packs his photo gear to go on-assignment, his preference is to carry the least amount of equipment possible. (Details on his two-bag system appear later in this chapter.) There are many advantages to working with portable shoe and handle-mount strobes. For starters, they are less expensive than studio strobes. These little strobes also pack lots of power into a small package, which is probably their biggest attraction, but the best reason for using these small strobes is that often they are the right tool for the right job.

Flash Fill

Whether you are working in color or black and white, one of the best things that portable strobes can do is serve as fill when shooting outdoors and sometimes indoors. When using fill flash, color transparencies seem to sparkle, and black and white photographs have more "snap." Don't get us wrong, we are not knocking real available light. It can look great, but that's only true when you have some control over where the photograph is going to be made. As you will discover by reading some of the adventures scattered throughout this book, the location that works best, or must be used, doesn't always have ideal lighting conditions. Unfortunately, you still have to bring back acceptable and technically, as well as aesthetically, pleasing images. That's where using fill flash can make the difference between a good shot and a great one.

Leaf-shutter cameras, like the Hasselblad, synchronize with electronic flash units at shutter speeds up to 1/500th of a second, and using flash fill with a leaf-shutter camera has always been easier than it is in 35mm, but that's changing. Newer cameras, such as Nikon's N90s and f5, have higher synch speeds than previously available SLRs, and when they are used with a complimentary flash unit, such as the SB-26, they have automatic fill flash capability.

What is the secret of good fill flash? Basic photo books are full of rules to follow that help you obtain the mathematically correct

Flasl

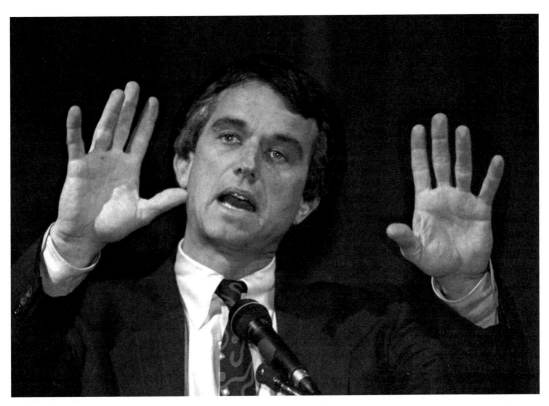

Figure 3.3 For this photograph of Robert F. Kennedy, Jr., the camera was mounted on a monopod. A small flash was used, set at two stops below normal, to fill in the shadows under the eyes. Film was Fuji 800 ISO film rated at an Exposure Index of 1600. Exposure was 1/60 second at f/4. Photograph © *The Denver Post*/Barry Staver.

white or bright wall is better than having them stand or sit in the center of a room. It never hurts to look around or ask. This trick only works with white or neutral-colored walls. Bright red or green walls can add unwanted color to your portrait subject's face.

- A shoe-mount electronic flash unit—held off-camera with a long cord—can add just a touch of extra light to fill in those shadow areas under eyes that are created by harsh overhead lights.

The photograph of Robert F. Kennedy, Jr. was taken during a speech he made on a college campus in Denver, Colorado. The room had two weak spotlights that were aimed haphazardly at the stage. Arriving early for the assignment provided time for Barry Staver to find the building electrician and get his help in

aiming the spots toward the podium. The speech was photographed with two basic lenses: an 80-200mm f/2/8 zoom and a 300mm f/4. For general work, the 300mm f/4 is a good choice for a telephoto lens. It is much smaller than its big brother, the 300mm f/2/8, and weighs far less.

As mentioned earlier, capturing action successfully in low light sports requires fast lenses, but the 300mm f/4 is adequate for stationary subjects like people making speeches. The podium was on an elevated stage, placing Kennedy head and shoulders above the crowd, which created other kinds of problems. For example, when you look up at someone from close range, what do you see? You see right up their nose! It can't be missed, it's sitting right in the center of their face. Editors don't like this particular camera angle any more than photographers that care how their work looks. Using a 300mm lens allowed Barry to be at a camera position further back from the stage, which reduced the angle from camera to subject.

Flashy?

Sometimes the best way to deal with available light situations is to use portable flash units. There are many electronic flash units today that are as sophisticated as the cameras they are attached to, but the key to evaluating them is the old standard: the guide number or GN. The key word in this phrase is "Guide," and it is just that—something that just gets you started with your own more precise tests. Every photographer has their own (and maybe their client's) taste in color and exposure to consider. With transparency films this can mean a fairly wide range in exposure to get what you consider acceptable. While working on this book, Joe Farace, obtained a copy of the German DIN standard for determining guide numbers. Here are a few excerpts:

Trivia from Joe: What Does DIN Mean?

Deutsche Institut fur Normung (German Institute for Standardization) or DIN specifications are issued under the control of the German government. Some are used on a worldwide basis, especially related to computers, to specify the dimensions of cable connectors, often called DIN connectors. Many

digital cameras connect to computers with cables that have DIN connectors.

> Flash meters cannot be used for accurate determination of a flash unit's guide number. . . . The Guide Number of a flash unit is to be determined by means of a photoelectric light output measuring instrument whose PhotoCell exhibits a spectral sensitivity matched to that of the human eye. The light output measuring instrument measures the light intensity over a specific period of time and then calculates the flashgun's guide number by means of an equation.

This equation determines the value of the guide number as the square root of the Integral of the light measured over a specific period of time multiplied by a constant DIN called "C2." DIN goes on to explain that C2

> is based on the general lighting conditions for a normal flash shot, such as reflections from the subject, reflections in the room, etc. The equation yields only one guide number. This guide number applies to an ordinary flash shooting situation (such as usually found in amateur photography).

While this procedure does not produce an arbitrary number, the use of a constant like C2 to obtain an "official" Guide Number can cause variations depending on the type of photographs you make. If you don't understand all this, don't worry—neither do we. The point of bringing it up at all is to let you know that while much of photography is based on science and technology, you should not let that get in the way of common sense and practical experience. When fully-automatic cameras were relatively new, an old friend of Joe Farace's complained about the photographs she was getting with her new Nikkormat EL. "What's the problem," she asked. "Well," he said, "this camera is effective under 90 percent of lighting conditions, but you make most of your photographs in that other 10 percent." The same concept is true for Guide Numbers.

If you happen to make most of your photographs outside the conditions found in an "ordinary flash shooting situation," it's time to shoot a few tests. Many labs (see Chapter 5) will provide

free processing for tests where each frame of the film contains a Macbeth Color Checker or similar test target. When used for these free tests, Joe's Macbeth Color Checker has paid for itself many times over.

Flash on Location

When Joe Farace packs his photo gear to go on-assignment, his preference is to carry the least amount of equipment possible. (Details on his two-bag system appear later in this chapter.) There are many advantages to working with portable shoe and handle-mount strobes. For starters, they are less expensive than studio strobes. These little strobes also pack lots of power into a small package, which is probably their biggest attraction, but the best reason for using these small strobes is that often they are the right tool for the right job.

Flash Fill

Whether you are working in color or black and white, one of the best things that portable strobes can do is serve as fill when shooting outdoors and sometimes indoors. When using fill flash, color transparencies seem to sparkle, and black and white photographs have more "snap." Don't get us wrong, we are not knocking real available light. It can look great, but that's only true when you have some control over where the photograph is going to be made. As you will discover by reading some of the adventures scattered throughout this book, the location that works best, or must be used, doesn't always have ideal lighting conditions. Unfortunately, you still have to bring back acceptable and technically, as well as aesthetically, pleasing images. That's where using fill flash can make the difference between a good shot and a great one.

Leaf-shutter cameras, like the Hasselblad, synchronize with electronic flash units at shutter speeds up to 1/500th of a second, and using flash fill with a leaf-shutter camera has always been easier than it is in 35mm, but that's changing. Newer cameras, such as Nikon's N90s and f5, have higher synch speeds than previously available SLRs, and when they are used with a complimentary flash unit, such as the SB-26, they have automatic fill flash capability.

What is the secret of good fill flash? Basic photo books are full of rules to follow that help you obtain the mathematically correct

ratios of daylight to flash, but only you know what looks best. All you need to do to find out is to shoot a single roll of your favorite type of transparency film and bracket like crazy. Shoot a few frames with the flash set on manual, but be sure to try all your flash's automatic settings. For each frame you shoot, keep records of what your camera and flash settings were, then have the film processed but not mounted so you can make side-by-side comparisons. (You save a few bucks, too.) Compare your notes with the processed film, and you should find the answer to what's the right balance for fill flash right on your own lightbox.

You may want to include a Macbeth Color Checker in the shot. If you are concerned about skin tone, make sure the tests includes a three-quarter view of a person in the frame. With automatic cameras and sophisticated flashes, you can also bracket by changing the camera's exposure compensation dial in 1/3-stop increments.

Working on location often means making the most of a difficult situation. Both of us have found that, more than once, the portable flash has made the difference between a good photograph or not getting any picture at all.

Boxing Day

When you encounter the photographic situation from hell, it's not a pretty sight This is what occurs when you arrive for a shoot and all of the items on the aforementioned checklist come up empty. What happens when the lights are already up all the way and no additional lights can be aimed at the subject? The event is dead center in the middle of the room and cannot be moved towards a reflective wall, and, to add insult to injury, no flash is permitted. The assignment was sports and Barry Staver already had his fastest lens mounted on the camera.

What's an available light photographer to do? Do you give up and call it a day? Rant and rave and demand to speak to the manager or organizer of the event? (For what its worth, nine times out of ten, this doesn't help much.) Or do you persevere and dig deeper into your available light bag of tricks? If you have not already guessed it, we think that number three is the correct answer.

The assignment was a Golden Gloves tournament that was being held in the grand ballroom of an airport hotel. The three-day event would see scores of bouts in a three-ring venue. The

room was lit with bare bulbs inside large reflectors hanging from the ceiling, and there weren't many of them, which left plenty of dark areas on the floor. Flash was not permitted because it could momentarily blind the fighters, and it was obviously impossible to move the rings into better light. Of the three rings in the room, one was well-positioned under the lights, and the other two were in what seemed like total—photographic, anyway—darkness. Can you guess which fight became the photographer's featured event?

The next trick in the available lights bag 'o tricks comes from the old sports photographers: Create your image just as the action peaks. There is a split second when movement actually stops in almost all sports. In basketball it can be when players reach the apex of the jump, a split second before gravity brings them back down. It happens in football when the quarterback has his arm all the way back ready to throw, just at the completion of the throw, and in the instant when the receiver has the ball drilled into him. It happens in boxing just a split second before the punch is thrown and just as it lands. Look for those moments and be ready to shoot. Be prepared and you will make your own luck and be able to capture the best action in really low light.

Here's another bag o' tricks tip: Use a shorter lens and don't fill the frame as tightly as you normally would. When the shot is cropped a bit looser, any blur in the participants will be perceived as less. There may be movement in the fighter's arm, but it will just add realism to the final photograph. Had one or both men been blurred more than what you see in the illustration, this photograph would have lost its editorial value and become more artistic. (See Figure 3.4 in color insert.)

Wildlife

Wildlife photography is an art unto itself. Successful shoots often involve 95 percent waiting and 5 percent shooting. Truly successful wildlife photography is a combination of careful planning, a knowledge of animal habitats, and an arsenal of long lenses. Most wild animals fear humans and prefer to stay far away, but many animals are active in the early morning or late afternoon. This is the time when they come out of hiding and, in many cases, head for water. In previous chapters we have talked about the challenges of shooting at the golden hour, and the

Figure 3.5 The antelope was photographed at sunset in the Wyoming tundra near Rawlins. The animal is backlit and required a 600 mm f/4 lens in order to capture a usable exposure with Kodachrome 64 film. A monopod supported the lens. Photograph © Barry Staver.

addition of an animal in that fabulous light can improve a landscape a hundred fold. It's at this golden hour that long and fast lenses are needed to capture both animal and light.

Another consideration when using fast lenses is depth of field, the portion of an image that is in focus. Several factors affect depth of field, including the focal length of a lens, the distance at which it is focused, and the aperture at which it's set. Any lens that is stopped down during the exposure will produce an image with more depth of field, than when the lens is set at its maximum aperture. With distance to subject and f/stop being equal, a wide angle lens will have more apparent depth of field than a telephoto lens—more of the subject will be in focus from front to back. The depth of field of a fast telephoto lens set to maximum aperture can be as shallow as a few inches.

Life is full of trade-offs, and your choice of fast lenses is no exception. The gain in lens speed allows for better low light photography, but fast lenses cost more and they are heavier and bulkier. An f/2.8 lens is easier to focus in low light than an f/4 or 5.6 lens, as more light comes through the glass, which puts less strain on your eyes. If you have access to both fast and slow lenses, here's an experiment you should try at home, in the local gymnasium, or any other dimly lit venue. Spend one hour constantly looking through and shooting with the slow lens, then switch to the fast one for another hour (that's the average amount of time a news photographer would be shooting a basketball, wrestling, volleyball, or hockey event). Which was easier and put less strain on your shooting eye? (For you trivia buffs: Barry shoots left-eyed, while Joe is a right-eyed photographer.) While the fast lenses—especially telephotos—will be easier on your eye, it's also going to be harder on your back. These long lenses are big, bulky, and heavy, and you have to be in good shape to lug them around all day.

Sweating the Light

Imagine a very difficult, long, hard, and cold day at work. You have trekked eight or ten miles through the countryside carrying heavy equipment for a photo shoot. It's taken you all day, and you are beat and chilled to the bone. Wouldn't a nice hot sauna feel great? It would melt away all of the aches and pains from the day. On the other hand, have you ever gone into a hot sauna, completely clothed to take photographs? It's hot. The temperature inside a sauna can reach 180 to 212° Fahrenheit. Working in these kinds of temperatures could change your thinking about the pleasures of taking a sauna.

Mujahad Maynard is an Olympic wrestler who competed in the 1996 Summer Olympic Games in Atlanta. His training at the Olympic Training Center in Colorado Springs included running, weight lifting, stationary bicycling, and twice-a-day trips to the sauna to help him "cut weight," because wrestlers must weigh in at or below the correct weight for their class in order to compete. A photograph showing how thin he was before weigh-in was a necessity for Barry Staver's *People* magazine assignment.

In case you haven't figured it out, a sauna is a low light experience with an added difference. Illumination is provided by a

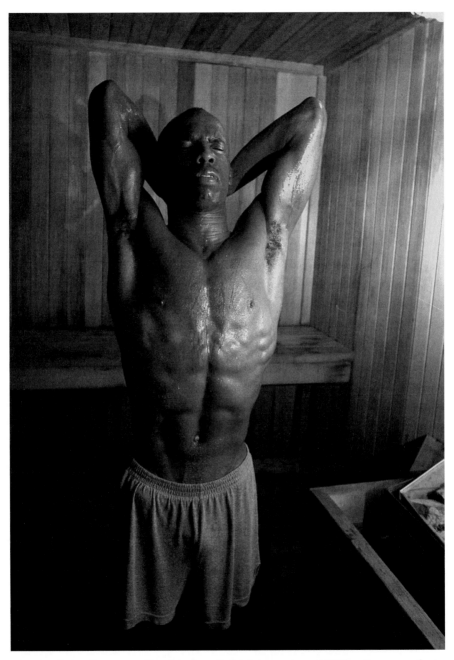

Figure 3.6 Exposure for this low light image was 1/25th of a second at f/4 on Fuji 800 color negative film. The fast 2.8 lens of the 20-35mm zoom made viewing and focusing in the darkened room easy. A small shoe-mount strobe, placed off-camera near the single light bulb, was used to provide additional illumination. Photograph © Barry Staver.

single light bulb. Within two minutes of entering the hot box, Barry's camera lens fogged up with condensation. When wiped off, it stayed dry only for about five to ten seconds providing almost enough time to shoot one frame of film. You may have had the same thing happen in winter when bringing cold cameras inside a warm building. The lenses and viewfinder will fog up until they attain room temperature.

The assignment seemed futile until an old locker room incident came to Barry's mind. After a Kansas City Chiefs season-ending victory, a colleague of his was not able to capture the jubilation in the locker room because of the same kind of fogging problem. His equipment was cold from shooting the December game and fogged instantly as it entered the hot, humid locker room. The following week just before kickoff for the playoff game, he placed a camera body and extra lenses in the locker room. They stayed warm and he didn't miss these post-game shots.

Maynard and the overheated photographer took a fifteen-minute break. The camera, a Nikon N90s with 20-35mm f/2.8 zoom, was left in the sauna. When they returned, the camera lens and viewfinder had cleared and the photo shoot was completed.

Gold Miners

It's difficult to make any kind of photograph in total darkness. Shooting fully costumed ninja's at night is tough. Shooting Doberman's at midnight is tough. Shooting in underground mines can be tough too, but none of these shoots are impossible. When a low light event becomes a no light experience, you need to add enough extra light for the photograph to succeed.

Light can be added in several ways. Turning on nearby light sources can often do the trick. Aiming vehicle headlights (turn the high beams on too) works well if they are nearby, although it's not a good idea to drive through the front of a house just to light the living room. If not used as main lights, these nearby and available fixtures can become accent lights, as you provide the main light from a flash or a continuous light source.

These miners are drilling underground at the Newmont Gold Mine in Nevada. To record the drilling, the battery operated lamps on their hard hats didn't even begin to provide enough light for the highest speed film available and without electrical

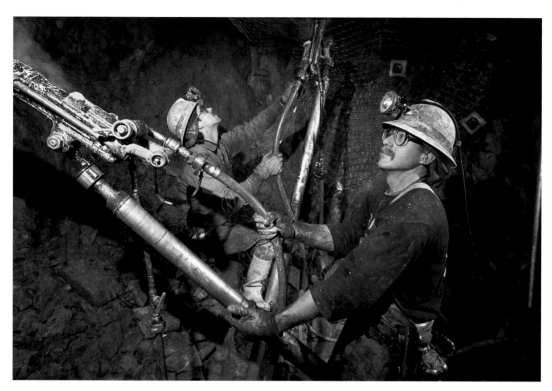

Figure 3.7 When working in a "no light" available light situation there is only one solution: bring your own. While working in a coal mine, Barry Staver used two shoe-mounted electronic flash units to shed some light on this dark situation. Photograph © Barry Staver.

power, continuous or hot lights aren't practical. What's more, the cabling necessary for them would also pose a safety concern in the darkened mineshaft. In difficult situations like this one, small portable electronic flash units are an excellent way to light up small areas. The photographer held one flash off camera high and to the left. An assistant aimed a second small strobe at the background and second miner.

A mineshaft is a far cry from a comfy studio and several factors need to be addressed to insure a successful shoot:

1. The absence of light on the subjects makes accurate focusing difficult. A seasoned veteran may be able to accurately "guesstimate" the camera to subject distance and pre-focus the lens, but a more foolproof way is to actually measure the distance with a tape measure and then set the focus on the

lens. If a bright enough light is available, it could be aimed at the subject long enough to focus on him.

2. It gets noisy once these drills are turned on. Ear protection is essential. Hearing anybody is impossible and hand signals won't work—remember it's dark in here. Pre-planning before the drilling starts is the only way to master the subject. Talk to the miners first to see how long they will drill in that spot. Tell your assistant exactly where to stand, check your camera settings and then be ready to shoot when the work begins.

3. Underground mines generally have wet spots as water seeps through the rock. Some mines are very wet, others not as bad. Be prepared with clear plastic bags to wrap around cameras and strobes, if necessary. Drilling into rock produces fine powdery dust that can ruin camera equipment. The plastic bags that will keep your equipment dry will also keep the dust off of it.

4. Having been "shot" many a time at the family birthday gathering—if nowhere else—we all know how bright a flash can be. A flash being fired in a darkened area can really blind someone. Check with the miners before the session starts. Do test firings to make sure the strobe's light doesn't hit them directly in the face.

5. This can be a hazardous and dangerous situation. Drills are heavy. They can slip out of operators' hands; drill bits can break. Rock can fly further than intended. Safety for the photographer and subjects is most important. Barry Staver hasn't been in a mine yet where the mine safety officer didn't accompany the photography crew and make sure conditions were as safe as possible.

A Two-Bag Lens System

Because Joe Farace specializes in fine art and stock photography, his lens needs, as well as how he carries them from place to place, are somewhat different from Barry Staver's. In this final section of the chapter, he shares with you a two-bag system for having the right lens available at the right time.

Too many miles in too many airplane seats and too much time spent in too many airports has left Joe with a fondness for traveling with as few pieces of photo gear as possible. This was brought home to him several years ago when he broke his "per-

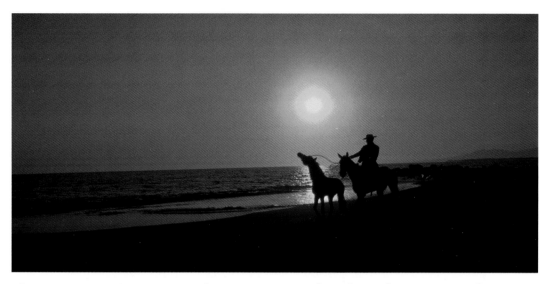

Figure 1.1 "Mexican sunset." This image was made with a Nikon camera and a 35mm lens. The film was Kodachrome 64. Photograph © Barry Staver.

Figure 1.6 Welder. "This shot was really exciting, because it was the only time in my life that I made a photograph and couldn't look through the camera," said Mary Farace. "He was using an Argon welder that would burn the retina of an unprotected eye." The worker was protected by a face mask, but she looked away when making an exposure. To photograph this mixed light situation, the scene was treated as an all-flash shot; no additional filtration was necessary. Two Bogen monolights 800Bs were used at full power for maximum depth of field. The main light used was a Westcott 45-inch umbrella, and the fill used was a 45-inch optical white umbrella. Shutter speeds were varied to get differing amounts of spark trails in the shot and ranged from 1/8 second to 8 seconds on Kodak 160 ISO color negative film. Photograph © Mary Farace.

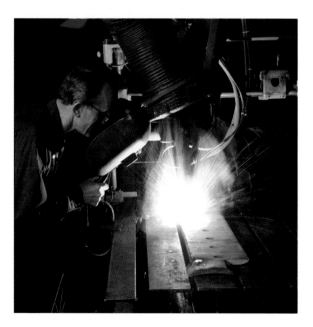

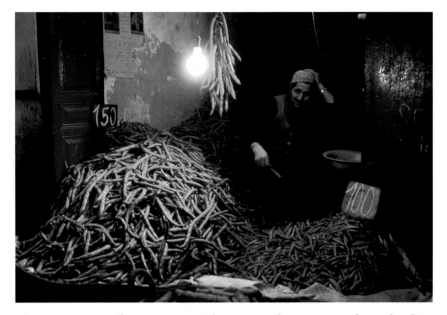

Figure 2.2 A Nikon camera with a 35mm lens was used to take this photograph of The Fez Merchant. It was shot using 200 ISO Ektachrome film. During the tour of the town, the in-camera meter was used to expedite shooting. The center-weighted feature of the meter provided a reading that kept the bare bulb at the top from "fooling" the meter. Photograph © Barry Staver.

Figure 2.7 Peaches. This photograph was exposed by using a hand-held meter and taking an incident reading. The low side light from the late afternoon diffused sun brings out the peach fuzz in great detail. Nikon camera with 85 mm lens and Kodachrome film. Photograph © Barry Staver.

Figure 2.9 Slide film was exposed in a Nikon camera with a 16mm fisheye lens. The camera was tripod-mounted for a time exposure of 5 seconds. The wide lens was needed to capture the entire building from the close distance. Photograph © Barry Staver.

Figure 3.2 The best sports photographs are generally shot from low angles, catching athletes such as gymnasts in the air as they perform leaps and jumps on the equipment. The photograph of the girl doing a flip on the balance beam was taken with a 400mm f/3.5 Nikkor lens (the 400 f/2.8 had not been announced yet) on Ektachrome 400 film (the fastest film available at the time). Photograph © Barry Staver.

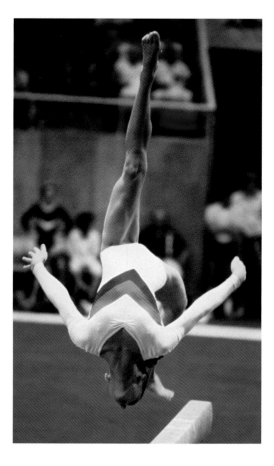

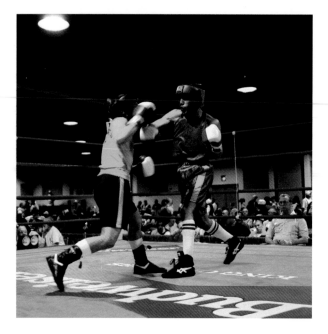

Figure 3.4 This photograph was taken with a Nikon 35-70mm f/2.8 lens. Shutter speed was 1/60 second at f/2.8. Fuji 800 ISO color negative film was pushed to 1600. Photograph © *The Denver Post*/Barry Staver.

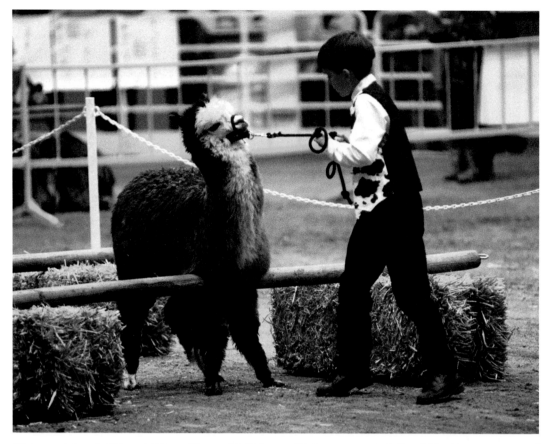

Figure 4.4 A Nikon N90s with an 80-200mm f/2.8 zoom set at the full 200mm captured the moment of the boy with his llama. Fuji's 800 color negative film was rated at an EI of 1600. The photograph was exposed at 1/60th of a second at f/2.8 with a monopod used for support. Photograph © *The Denver Post*/Barry Staver.

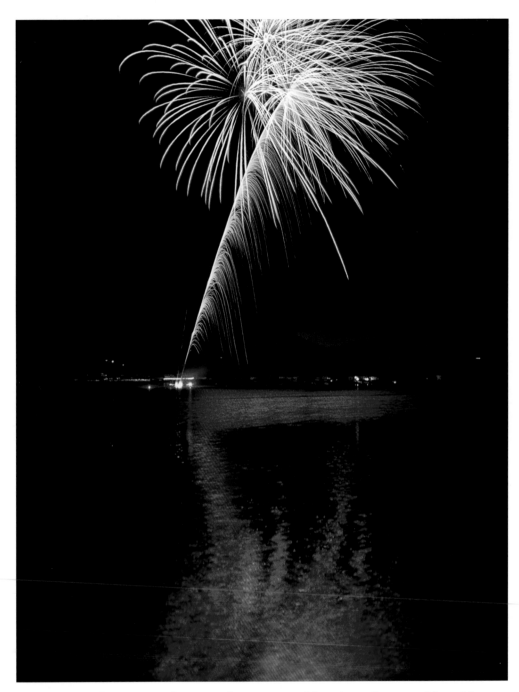

Figure 6.1 These fireworks were shot using a Slik universal U112 with quick release. The camera used was a Pentax 645 with 75mm f/2.8 lens shot on Fuji Velvia 50 transparency film. Bill Craig set up the tripod to view the fireworks making sure the full image was included in the frame. He used the camera's bulb shutter speed setting and a cable release to avoid camera movement. The shutter was open for the entire time that the fireworks were going off. The shot was taken near Westcliffe, Colorado on July 4th. (P.S. Take lots of insect repellent.) Photograph © Bill Craig.

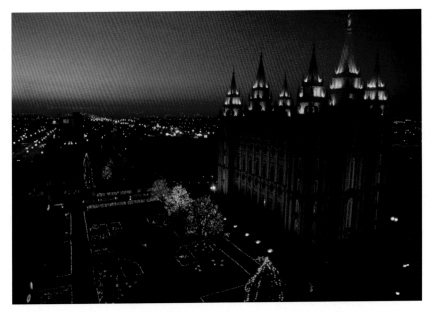

Figure 6.3a For this photograph of the Mormon Temple at Christmas time, several rolls of daylight and tungsten-balanced Ektachrome were exposed. Bracketing was extensive, and both vertical and horizontal images were shot. The tripods used were old and one was even borrowed! Photograph © Barry Staver.

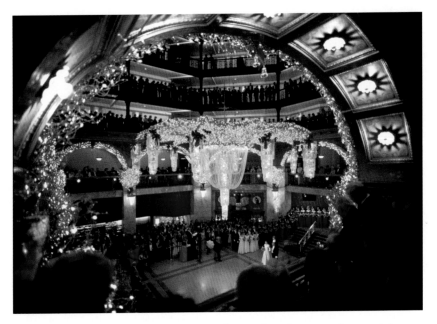

Figure 6.4 The Historic Brown Palace. The photograph was taken with a Sinar F 4×5 camera and a Nikkor 65mm f/4 SW lens. Photograph © Barry Staver.

Figure 7.2 For "Sun and Wires" a Nikon 600mm f/4 lens was used with a 1.6 teleconverter attached. An orange filter was placed into the 39mm filter holder in the lens for added color. Photograph © Barry Staver.

Figure 3.8 For the stock photographer, there is little difference between personal or business travel. This, one of Joe Farace's best-selling stock photographs, was made while he was on his honeymoon on the island of Kauai in Hawaii. Nikon FM2 with 200mm Nikkor lens on Kodak Ektachrome film. Photograph © Joe Farace.

sonal best" travel record by passing through twenty-eight different airports in one month. It was around this time that he developed the two-bag system for travel photography.

One If by Air

There is a noticeable difference between the amount of photo equipment he packs for personal travel compared to what he brings along when shooting stock travel images. When traveling for pleasure, he prefers to carry only a single camera bag. The full two-bag system is reserved for stock shoots or when traveling by car. His standard camera bag is the Domke F-2 and he has two: a blue one and an emerald green one. The blue bag is almost twenty years old and has traveled enough airline miles to earn its own frequent flyer points. The blue one is his secondary bag, while the green Emerald Edition bag is his number one bag.

There are very few "secrets" in photography, so it should come as no surprise that the common denominator for his choice of lenses is the use of zooms. Joe's goal in lens selection for travel photography is to provide a seamless selection of focal lengths within the range he prefers to work. Here's how he accomplished this with "Bag #1." Your own favorite focal length range may be different, but we think you'll get the idea.

When Joe purchased his first Nikon N90s, he ordered it with a 35-70 mm AF Nikkor zoom, an MF-26 multipurpose back, and an MB-10 vertical grip. At the time, he had no other autofocus lenses and added them—one at a time—to complement the 35-70 mm lens. The first addition was a Sigma 18-35 mm lens, which remains his favorite for scenic images as well as photographing automobiles. After that, he added a 70-300mm Sigma zoom, stretching the focal length range from 18mm to 300mm with just three lenses. This range, for Joe, is the essence of what he needs to photograph travel. Since travel photographers do not exist for natural lighting only, this bag also contains a Nikon SB-26 shoe-mount electronic flash unit to use for fill flash and those circumstances that demand a little extra light. With such few pieces of gear, there is plenty of room left in the bag for film—minus the boxes, of course.

One of the features Joe likes about the Domke F-2 bag is that it easily fits under an airline seat. In this day of more and more restrictions being placed on carry-on luggage, this can be a big advantage in getting on the plane with few problems. One of the

Figure 3.9 "Mr. Beethoven lives upstairs" was photographed on a pleasure trip to Germany using the photo equipment found in Joe Farace's Bag #1. Nikon FE2 with 20mm Nikkor lens on Kodak Ektachrome film. Photograph © Joe Farace.

disadvantages of placing any camera bag under an airline seat is that most planes vibrate like crazy. Over time and extended flights, these vibrations can cause camera body screws to loosen. That's why well-traveled photographers should always pack a set of high quality, small screwdrivers in their camera bags. Sometime during your travels, it's a good idea to take a few minutes to tighten these screws. On Joe's old Nikon FM2 and FE2s, the small, rubber eyepiece protectors almost always came loose during a long flight and, later on, would actually leap off the body while he was shooting. This malady does not seem to affect his current N90 and N90s bodies.

For a stock shoot, Joe always packs his Gitzo tripod, Safari monopod, and any other stick-like devices, such as reflectors, into a Lightware Pod Bag. When traveling by air, he wraps all of them in bubble pack and ships the bag as luggage. More often

than not, his second air travel bag is a Photoflex fanny pack. Joe likes the Photoflex bag because it's a bit wider than most photo and nonphoto fanny packs, allowing it to hold more film, filters (as you will discover later in Chapter 7, he is a confirmed filter fanatic), and a Nikon 28Ti or N90 body—without MF26 back and MB-10 grip. A fanny pack easily stows in an airplane's crowded overhead compartment, and he will usually wrap his coat around it for a little extra padding during bumpy flights.

The Full Monty

When traveling by car, Joe prefers to lug along two full bags. The second bag usually includes lenses that fit a category some may call "specialty" lenses. In his own case, this includes a selection of what is left of his original collection of manual focus Nikkor lenses. In your own situation, it may include lenses for photographing flowers, sports, or for use under low light conditions. His secondary choices (in increasing focal length range) include a 43-86mm Nikkor zoom, a 50mm f/1.4 Nikkor, a 55mm Micro-Nikkor, a 105 mm Nikkor portrait lens, and a 200mm Nikkor. One of the features that Joe likes about these manual focus lenses is that they are easier to use when working with filters, such as when shooting infrared film. In the secondary bag he keeps a back-up N90 body and a back-up electronic flash in the form of Nikon's new SB-28.

Depending on where he is going and how he is traveling, his "second" bag can take other forms, including a fanny pack, lens tote, or tripod bag. Depending on what he is going to be photographing, Joe may swap the fanny pack for a soft padded Out-Pack lens bag into which he stuffs a 400mm AF Sigma lens. The Saunders catalog shows a webbed belt that looks as if it fits the belt loop on the OutPack case, but while the belt fits through the loop, the hardware does not. Joe's wife Mary was kind enough to remove the belt clasp, insert the belt through the loop, then restitch the hardware back on. This allows Joe to wear the 400mm lens around his waist or sling it around his shoulder bandoleer-style. Also hanging from the belt is a small case that holds a 22-inch Photoflex LiteDisc collapsible reflector, which can be handy for adding a little "kicker" light to a person or object. When traveling by car, he does the "full Monty" and tosses all of the above bags into the back.

Figure 3.10 From inside bag #2, Joe selected a twenty-year-old manual focus 200 mm f/4 Nikkor and mounted it on a Nikon N90 to make this shot at Colonial Williamsburg in Virginia. Photograph © Joe Farace.

Security in Mind

One of the advantages of having a simplified camera bag system for travel is that it's a lot easier to keep all of your equipment close to you. One of the best security measures you can take to prevent theft is to have your bag on your shoulder—or around your waist—when shooting. On an extended European assignment, photographer Don Feltner broke Joe's rules for traveling light and it cost him dearly one sunny day in Paris. For this par-

ticular assignment, he was shooting with three different camera formats—35mm, medium format, and video. While shooting with the Nikons, he left his Hassleblads inside the tour bus of the band he was photographing. You guessed it: the entire camera system, along with all of the 35mm and 120 film he had shot in Paris, was stolen.

Storing equipment inside any vehicle—especially a car—is almost always an invitation to theft. One of the best things to do to prevent theft is to make it impossible to see the gear from outside. Keep equipment out of sight under a cover or in the trunk. Tinted glass for your automobile is a good idea (it keeps it cooler too) and so is a burglar alarm, but neither will scare off a determined thief. The main security advantages of the two-bag system are to keep it simple and keep it with you.

4 Fast Film

Fast film is photographic slang for a film that can capture images in less light than a slower speed film can. After all, too much of a good thing can be great.

Barry Staver

Photographic film contains layers of light-sensitive chemicals. Once exposed, the film needs to be developed before the latent image will be visible. Film varies by brand, type, and—most important for available light photographers—speed. Film manufacturers, such as Eastman Kodak or Fuji, make many different types of film, some of which are negative or print film, with the remainder being slide or transparency film. In general, negative film has the most *latitude* (the ability to provide proper exposure within a range of given f/stops), while slide film typically has less latitude. This means that your exposures must be more accurate when working with slide film, while negative film can be somewhat corrected—both in density and color—during the printing process. Don't let negative film be a crutch for you. As the great portrait photographer Leon Kennamer always said, "when you get it on the negative, even your proof prints will be great."

Film Speed

A film's speed indicates its relative sensitivity to light. Each kind of film has differing amounts of light under which they will perform at their best. If too much light is absorbed, all of the film

grains are exposed and you will see only black on the negative. If too little light is absorbed, no grains will be exposed and you will only see white—or clear—areas in the negative. A film's speed is a measure of its sensitivity to light, while the H & D (Hurter and Driffield) Curve provides density of grains per logarithm of exposure.

Originally, film speed was measured on a scale set by the ASA (American Standard Association). The higher the number, the more sensitive to light the film will be. ISO (International Standards Organization) speeds have replaced ASA speeds and are numerically identical. Nowadays, manufacturers produce fast films rated at ISO 800, 1600, even 3200, and few people actually use film with an ISO under 100. Yet, the lower the ISO number the higher the color quality and the finer the film's grain will be. Instead, most of us look for a compromise and will choose ISO 200 film as a general all-around film.

DX-Encoded Films

The days when you had to set—and sometimes forget to change—the film speed on your light meter or camera ended with the introduction of DX-encoded 35mm film. Most contemporary cameras automatically set the film speed by reading the bar code on DX-encoded film cassettes. DX-encoded films were developed by Eastman Kodak to help camera manufacturers make automatic cameras more automatic. The black and silver checkerboard pattern printed on DX-encoded cartridges provides compatible auto-exposure cameras with information about the kind and type of film you decided to use. When you load the cassette into the camera, sensors in the film compartment read the code and transfer the encoded information to a microchip located inside the camera.

DX-encoded films make it impossible to set the wrong film speed or to forget to change film speeds when you switch from one kind or speed of film to another. By providing information about the film's exposure latitude, DX encoding also helps the camera make important exposure decisions. DX-compatible cameras are programmed to a specific range of ISO film speeds. For SLR cameras, this range is typically ISO 25 to ISO 5000. For point-and-shoot cameras, the range may be narrower. If the camera cannot read the film speed, it typically sets a default of ISO 100.

While this film-speed range covers most ordinary films, there

may be occasions when you want to go beyond this range or when you want to set a speed differently from the manufacturer's recommendation. In such cases, it's usually possible to set a different film speed manually.

Get the Picture?

Back in Mathew Brady's days, photographic pioneers brushed a slow emulsion onto glass plates and, as noted earlier, propped up their subjects for long exposures. (They also had to process the film before the emulsion dried, but that's another book.) Fragile glass plates have long been replaced with the flexible film we use today, and film speed has increased enough so your subjects are free to move about and their actions can be frozen in time. Kodak's announcement that it would offer a 64 ISO Kodachrome film sent shock waves throughout the photographic community in 1974. Now, a 64 ISO film is considered ancient and painfully slow.

Anything higher than ISO 100 film used to be considered fast. Kodak's Tri-X black and white film, with its ISO rating of 400, was and still is, the best all purpose noncolor film available. People still marvel at the fact that you can shoot in low light with a high speed film such as that. Today, film speeds of 200 and 400 are quite common, with available high speed films rated at 800, 1600, and higher. Manufacturers of the disposable cameras load 400 and 800 film into them, too. You don't have to be a photojournalist to put these high speed films to work; they also see extensive use in portrait and wedding applications.

As in everything else in photography, there are trade-offs involved in your selection of a fast film. There are two important aspects of image quality that are related to film speed: sharpness and graininess. Sharpness refers to the film's ability to record fine detail with good definition. Generally, the lower a film's ISO speed is, the greater will be its ability to render subjects sharply. Graininess is the sand-like or granular texture that is sometimes noticeable in enlargements. Grain is a by-product of the structure of the film's light-sensitive emulsion and is usually more visible in images made with faster speed films. The traditional method for increasing a film's sensitivity was to use more and larger film grains so they could absorb more light. As film speed increases, so does the size of the grain pattern. Recent improvements in film technology, such as Kodak's introduction of the T-

Figure 4.1 For the image of the "jogging pigs," Barry Staver used a Nikon camera, a 300mm f/2.8 lens, Kodachrome 64, and a monopod supported close to the ground. Photograph © Barry Staver.

Grain emulsion, have minimized the problems of graininess—even with fast films and at high levels of enlargement. Most Kodak films now take advantage of this new technology in some or all of their image-forming layers. Fuji offers its Distinctive Developing Grain technology in most of its film line to raise effective film speed. When used with the complimentary Super Uniform Fine Grain technology, Fuji can produce a film like MS100/1000 professional color slide film. This film has a nominal film speed of ISO 100 but can be push-processed (see Chapter 6) to an Exposure Index of 1000. If you are not familiar with EI, it will be explained in a few pages.

The jogging pigs were photographed by Barry Staver while on assignment for *Life* magazine. A university study in Arizona involved running pigs around a track and measuring their heart rate, which was then compared to that of humans. For whatever reason, it seems that pigs and humans have similar circulatory systems.

It's hot in Arizona. No, it's unbearably hot in Arizona in the summer when this assignment was shot. It was so hot that the pigs could only be run before dawn, the coolest time of the day—

slightly before the golden hour. Once the mental image of pigs jogging sinks into your mind, it doesn't take long to realize that anything running is an action photograph. In this situation, you have a predawn, still in darkness, photo session featuring action. The naive photographer figured the image had to be shot on Kodachrome 64 to give it the high quality *Life* magazine would require, forgetting that the magazine's forte was in its use of great images regardless of media type, size, or film speed used. The photographs were taken just as the sun rose above the horizon, during the last few minutes of the animals' workout.

The relationship of film speed to grain and sharpness sometimes forces photographers to make a crucial decision about quality. With action subjects, like the jogging pigs, the photographer had to decide if he wanted to use a slower film for sharper fine-grained pictures, or a faster action-stopping film. If you opt for slower-speed film, you will lose some action-stopping ability; but if you choose a faster film to stop action, you will get increased grain. If Barry had to do it over again, he would have used a faster film, allowing for more depth of field and a less stressful time wondering if the photographs would turn out.

Let's Go to the Movies

Film, whether it be for still or motion cameras, is manufactured with a specific ISO or speed. It needs a certain amount of light passing through a high quality glass optic to record an image onto its emulsion. A video camera, on the other hand, can use a low quality lens with less resolving power to put its image onto magnetic tape. For this reason, camcorder owners can produce great videos in low light conditions. Traditional silver-based cameras cannot compete in these kinds of low light situations. However, motion film cameras can achieve better results in low light than still film cameras, because they are running the film through the camera at thirty frames per second and are not capturing separate, discrete images. It is more than possible, even likely, that many of those frames have blurry images. Movie patrons don't see the blur because of a peculiarity of the eye called "persistence of vision." Another reason is that a movie or television show shot on film (any Rob Bowman-directed episode of *The X-Files* comes to mind) can successfully be dark and moody, while a newspaper or magazine image shot in the same darkness would not reproduce well from a printing press.

Tip from Joe: Persistence of Vision

I grew up with the concept that "persistence of vision" was an accepted phenomenon that allowed viewers to see a collection of still (and maybe blurred) images as a motion picture. The way I learned it is that it is similar to what Roget theorized when describing the phenomenon of spokes of a wheel appearing to be curved when viewed through a series of vertical slits. He mentions the

> illusion that occurs when a bright object is wheeled rapidly round in a circle, giving rise to the appearance of a line of light throughout the whole circumference; namely, that an impression made by a pencil of rays on the retina, if sufficiently vivid, will remain for a certain time after the cause has ceased.

In a white paper on persistence of vision I found on the Internet, Bill Nichols and Susan J. Lederman suggest that Roget might be referring to something psychologists call "positive after-images." They state that "positive after-images retain the color and brightness of the original stimulus. Common sense would suggest that the positive after-image is a plausible explanation of motion perception in film since it allows one image-frame to 'bleed' into another."

The illustration was taken by Barry Staver while on location in Yugoslavia where Tom Selleck was playing the lead role in a movie called "High Road to China." This action-adventure film included an interior scene in a bar where Selleck was bragging about his aerial exploits to a group of British soldiers. The actual filming took place in a cold, dark, and damp indoor arena in the coastal town of Opatija. The scene was backlit so that cigar smoke would be visible and chemical drops were continually placed into Selleck's eyes so they would look bloodshot and bleary. Unless a camera is enclosed in a soundproof "blimp," still photographs are not permitted on a film set except during rehearsals. During the actual take, the blimp will hide any camera noise from the audio recording of the scene.

The lighting for the scene was moody and dark, and the increase in film speed was needed to prevent camera movement and provide some depth of field. In this crowded situation, it was not possible to use a tripod or monopod. The combination

Figure 4.2 For this image of Tom Selleck, a Nikon camera with a 180mm f/2.8 lens was used. The film was Kodak Tri-X, a 400 ISO film actually exposed at 800. Photograph © Barry Staver.

of a cold location (Barry was shivering), low lighting, and moderate telephoto lens invited camera shake. Pushing the film one stop (see the next chapter for details on how this works) may not seem like much of a gain, but it can make the difference between a usable image or a blurred unsatisfactory one. The usable ones always look better.

ISO vs. EI

The ISO rated speed of a film is designated by the manufacturers, who do a series of subjective tests to decide the designation for the film. An Exposure Index or EI is the speed at which the photographer actually shoots that film. This is accomplished by changing the camera's or the hand-held meter's film speed control to reflect a number different than what is recommended by

the manufacturer, therefore deliberately underexposing or over-exposing the film. In the past, the way most photographers handled working with exposure indexes was by simply changing the film speed settings to reflect the EI in use. With the advent of DX-coded films, cameras began sporting exposure compensation control dials that let shooters automatically make plus or minus stop adjustments in exposure. Nowadays, most electronic cameras allow you to set exposure compensation in 1/3 f/stops. For example, Barry Staver likes to overexpose some negative films by 1/3 stop to add greater shadow detail to the final image. This means that for ISO 200 film he is shooting at an Exposure Index of 134. Similarly, when underexposing 200 speed film by 1/3 stop, his EI would be 266. Your EI can also be adjusted by using lab processes, such as pushing or pulling. These topics are covered in the next chapter.

Fast Film, Fast Talk

The vast majority of magazines still prefer a transparency over a color print for printing. Although that preference is changing, there is still the demand to use "chrome" films whenever possible. Color negative film is ahead of its transparency brethren in faster speed and better quality, making the requirement for slide film in low light more difficult. Since most photographers use daylight balanced slide film, it's a surprise to us—but a pleasant one—that Kodak offers an ISO 320 transparency film balanced for 3200° K. If needed, this remarkable film will even push one stop (see Chapter 5) to an Exposure Index of 640.

Time magazine is notorious for making last minute requests of its photographers. After all, it's a news magazine that needs to be current on a weekly basis. Barry Staver's assignment was to photograph nationally syndicated radio talk show host Ken Hamblin while he was on the air. Mr. Hamblin's three-hour program was scheduled to start within one hour from the time Barry received the assignment. Hamblin's studio is a forty minute drive across Denver from Barry's office. A frantic call to the producer provided information on what the studio interior looked like. The news was not good: dark walls, very high ceiling, in a small room, with a window directly behind Hamblin's head. This was a photographer's nightmare—made somewhat less threatening by the friendly invitation to "come over as soon as you can; we'll help out in any way possible." The request to

Figure 4.3 The Kodak ISO 320 "tungsten" slide film was the key to success for this assignment. This photograph of talk show host Ken Hamblin was taken at 1/30 of a second at f/5.6. Photograph © Barry Staver.

have the studio professionally lit, with the chairs, desks, and microphones rearranged to the photographer's advantage in one hour, was drowned out by enormous laughter at the other end of the phone.

Barry walked into the studio at about 1:10 P.M., ten minutes into the show. While Hamblin was on air, three quartz "hot lights" (Lowel Totas and Omnis) were positioned around him, hand-held meter readings were taken, and the session began. So called "hot lights" were chosen because they would be less distracting and quieter (without the popping sound or the recycle whine if flash had been used) for the subject, and would provide the photographer with better light for focusing. Besides, it was

the only high speed slide film Barry had with him. The Lowel lights were also easier to reposition as shooting angles changed. Because Barry could see the effect of the lighting he was using, additional meter readings weren't required and reflections and glare could be easily seen and adjusted during the shoot—not afterward when it would be too late to correct. Using so called "hot lights" also meant that Barry didn't have to take time to shoot Polaroid test shots.

During the shoot two Nikon 8008s were used with 24mm f/2.8; a 35-70mm f/2.8 and an 80-200mm f/2.8 lens interchanged as needed. Shutter speeds ranged from 1/125 at f/2.8 to 1/30 at f/5.6. The wide angle lens can be hand-held at 1/30 easier than the 80-200. The f/5.6 opening gave more depth of field to this view, and the slight blurring of the hands adds a bit to the image as Hamblin gets passionate, excited, and expressive about his points of view during his radio show.

Take Time for Testing

"Just tell me what the speed of this film is and I'll know how to shoot it!" That's what Joe Farace's partner and wife, Mary Farace, asked when she noticed that her Kodak T-Max 100 negatives seemed "thinner" than they should be. If the term "thin" is new to you, here's an explanation: the film is still the same thickness that it always was, but the density of the exposure made the processed image lighter and less dense than a well-exposed negative. Conversely, if a negative is "thick" or "heavy," it is overexposed or overdeveloped, and maybe both. It looked like a trend. All the black and white film Joe and Mary had been shooting on location or in the studio appeared slightly underexposed. Too often film testing is relegated to newly introduced films, instead of making it an ongoing process. It is easy to become comfortable (maybe complacent is a better word) with a certain kind of film and the way it is processed. Joe and Mary were so busy with new assignments they hadn't taken the time to shoot film tests.

When Kodak originally introduced both T-MAX emulsions, Joe made both the ISO 100 and 400 films his standard black and white film, but lately, something had gone wrong. He started by eliminating obvious problems. First, he called the manager of the photo lab he used and asked if they had changed their method of processing black and white film. "No," Kevin said,

"not since we switched to T-MAX developer several years ago." Joe and Mary had had a few problems with one of their 150mm Hasselblad lenses, and although it had been repaired, it might be the culprit. Their Flashmeter III had been calibrated by Minolta, and for the first time in a long while all the flash meters in the studio matched.

They needed to do a film test to find out exactly what was wrong. The methods described here are so simple that any shooter, regardless of experience, can use them. The tests combine common sense along with the teachings of legendary portrait master Joe Zeltsman, who used similar procedures to determine a film's base density of exposure when using a set of "nailed down" fill lights.

Joe started by loading a Hasselblad back with a roll of Kodak T-MAX 100. Studio lighting was the same Bogen monolights routinely used for business portraits. His subject was Mary, who held a Macbeth Color Checker with a 3M Post-it note stuck to it listing the lens and aperture used. Starting one stop less than the Flashmeter III showed, Joe bracketed at half stops until two stops over the indicated aperture. He did the same thing with both 150mm lenses and sent the film to the lab with instructions to select the best negative and make a 5x7 print from it. The Zeltsman method calls for 8x10 prints to be made from each negative in order to make comparisons. You can do this too.

When Joe got the test print back, it was (technically) the best black and white print he had seen in a long time. The meter indicated f/11.8 and I had typically set the lens between f/11-16. The tests showed that the best negatives were produced between f/11-8, which is a full stop more. This suggests an EI of 50 for T-MAX 100 *under their lighting conditions and lab processing*. Your lab may use different materials and processing equipment, so please use these results as a basis for conducting your own tests.

After this was completed, Joe thought they should test other film types too. He had been using Kodak VPS III color negative film because its low contrast and neutral skin tones make it a useful tool for photographing people. Although VPS III is also rated at an ISO of 160, Joe had found using an EI of 80 or 100 produced the best-looking prints. When he heard that Konica's SRG-160 color negative film claimed to have a true ISO speed of 160, he did two different tests with Konica's film. In the first, he duplicated the methodology of the black and white tests and asked the lab to pick the best negative from a 120-roll of Konica SRG-160 and make a machine 5x7 print from it. The results

showed an EI identical to Kodak VPS, but what intrigued him more was the quality of the color. The skin tones looked slightly warmer and other colors seemed more saturated than results from Kodak's VPS III. The grain structure looked pretty good too.

His second test was a head-to-head comparison of Konica SRG-160 and Kodak VPS III films. In this test, Mary photographed three children, one at a time, on each type of film—without a Color Checker present. Joe sent the film to his lab and asked them to make 5x5 machine proofs of each image. When the proofs arrived, he picked similar pairs of prints (one for each film type and child) and showed them to different people without identifying which prints were made with which film. First, he showed them to typical consumers who were asked "which picture do you like best?" Typically they picked two out of three made with the Konica film, although sometimes they picked a different two out of three. Next, he asked several graphic artists for their opinions; they selected all three prints made with Konica's film. The reason given was that although they weren't "sure the colors were natural," the Konica prints had a "punchier" look.

Before Joe ran into the underexposure problem that kicked off this round of testing, he had started testing 35mm transparency films for stock photography. He was in a rut. Most of his work used Kodachrome and Kodak's Ektachrome EPN, but for tricky night shots, he shot Fujichrome Provia ISO 1600 film.

Joe's first series of tests were made with Fuji's Velvia ISO 50 films and Kodak's EPX Ektachrome ISO 64 film. Shooting at an elevation of 13,000 feet in Colorado's high country, he found the colors produced by Kodak's film to be neutral and the rated ISO to be "right on." When he changed the EI to 80, his photographs took on drama and produced spectacular scenic images. Then he loaded a few rolls of the Fuji film. His first thought when looking at the Velvia slides was "WOW." Here is a fine-grained, intensely sharp film that produced excellent results at its stated ISO 50 rating, and breath-taking images with modest underexposure. Velvia is a slightly "contrasty"—some may think more than slightly—film that can't always handle a wide variation in exposure zones within a single image. In moderately "contrasty" light, it produces eye-popping scenics, or, if you prefer, you can create strong, graphic images.

The point of this discourse is that, whether you shoot for fun or for a living, you should institute an ongoing series of film tests using some of the above described methods. Even when

you find a film type or group of film types, keep testing as new emulsions are introduced by Kodak, Fuji, or Konica.

Llamas?

There are always those situations where photographs are wanted and needed and the light just isn't there. Sure, it is there in a physical sense, but not in a practical and usable sense. Kids appear in school plays and musicals with little or no theatrical lighting; the school band is playing at half-time of the night game in an old county stadium with two small banks of thirty-year-old lights; the scout troop is handing out merit badges in the church basement and two of the four fluorescent fixtures have burned out tubes; and junior livestock handlers are showing animals in a large, dimly lit arena, filled with dust from the dirt floor.

All of these situations need to be recorded on film, whether for a family's scrapbook or for the local newspaper. Fortunately, fast film allows for this photographic record-keeping to happen. Most point-and-shoot cameras have long enough zoom lenses to adequately capture these events, but the maximum opening of the lens leaves a lot to be desired in low light settings. Typically, when the lens zooms to its telephoto lengths, its aperture gets smaller. Often it shifts to f/5.6, f/8, or smaller. A photographer shooting under low light at f/8 will need the highest speed film to be found—and then some. Taking a roll of ISO 1600 color negative film to any one of the events listed above makes good sense.

The little boy coaxing his llama over an obstacle took place in the center of a large and old arena at the National Western Stock Show complex in Denver, Colorado. (See Figure 4.4 in color insert.) Over the years, the bare bulbs hanging from the ceiling have had reflectors added to them that provide one stop more light than available darkness. On top of that, the dirt floor does not reflect light like a smooth gymnasium or ice arena floor does. In short, the lighting for this kind of scene is flat.

For the illustration, a Nikon N90s with an 80-200mm f/2.8 zoom was set at the full 200mm length and was used to capture the moment. The film used was Fuji 800 color negative and was exposed at an EI of 1600. The photograph was exposed at 1/60th of a second at f/2.8 while the photographer was inside the arena—but at its edge.

A spectator in the stands would be at least another thirty feet away. The addition of on-camera flash from the stands would have no effect, since the distance to the subject exceeds the effective flash distance of the average point-and-shoot camera. If this was your child, it would still be wise to *try* to photograph this scene from the stands with a point-and-shoot camera. At full zoom, the automatic camera would probably fire at 1/8th second at f/8. By using ISO 800 film, holding very still, and lightly pushing the shutter release, you might just make your own luck (see Chapter 1) and obtain usable images.

Round Ball

Fast film has improved indoor sports photography dramatically. Photographers used to stand on the sidelines of basketball courts firing flash bulbs as they exposed 4x5 sheet film. You can imagine the chaos that caused players as they were momentarily blinded by the bright flash. Do you suppose games were decided because the home team convinced the hometown paper to fire flashes when the opponents had the ball? Let's hope not.

Sports arenas are still not illuminated as brightly as photographers might like, but as lighting technology improves they do get brighter. The photographs made in sports arenas improve as high speed film improves and pushes the envelope of speed. These days, many newspapers and sports magazines rely on large strobe units hidden up in the catwalks of arenas to provide additional light, but usable images can be obtained with high speed film and available light. It's not necessary to purchase $20,000 worth of lighting and radio-controlled triggering equipment to shoot the Friday night basketball game. You should, however, have a fast lens and high speed film. Access to courtside is not required either. Often all available floor space is taken by television and print photojournalists. Overhead shots can still be used to capture peak action.

This illustration shows a basketball game between Colorado State University and Cleveland State and was photographed from the bleachers using a Nikon F5 camera with a 80-200mm f/2.8 Nikon zoom lens. From this vantage point, it's easier to follow the ball and the action and increase the percentage of usable images. The Director of Photography at *Sports Illustrated* once stated that a 20 percent ratio in sports photography was phenomenal. He expected seven images to be in focus for each roll

Figure 4.5 This basketball game between Colorado State University and Cleveland State was photographed from the bleachers. A Nikon F5 camera with 80-200mm f/2.8 Nikon zoom was used. Photograph © *The Denver Post*/Barry Staver.

of 36-exposure film shot by the most talented group of sports shooters in the country! (This was in those dark days before auto-focus cameras and ISO 800 speed film, so undoubtedly the percentage of usable shots per roll has gone up.) You still should not expect every sports photograph to be in focus or capture peak action. Remember, if you shoot long enough and well enough, you will again create your own luck.

Sa-Sung

Sa-Sung is Korean for Grand Master. C.E. Sereff is the only non-Asian taekwon-do martial artist in the world to attain the title of Grand Master. He received this title at his recent promotion to 9th degree Black Belt. He has spent his entire adult life studying and advancing the martial art of taekwon-do. As President of the United States Taekwon-Do Federation, (part of a larger international organization) he oversees 18,000 students, instructors, and staff. Advanced students fortunate enough to live near his Denver area gym and federation headquarters, can actually train with the Grand Master during his weekly black belt class.

Taekwon-Do practitioners perform kicks and hand techniques from both the ground and while flying through the air. They break boards and concrete tiles with their bare hands and feet as well. Capturing these feats on film requires not only a knowledge of photography but a knowledge of the art as well. Timing is very important, since many techniques are done only once. The photo session with Sereff was for a photo page layout in the *Denver Post*. Barry Staver is a black belt in the USTF and has trained in the gym with Grand Master Sereff, thus providing both photographic and technical expertise. To insure the success of the shoot, he went to a colored belt training class on a Monday night for a practice round. Tests were shot and processed film was checked for the best combination of available light/strobe fill.

The Wednesday Black Belt class was then shot with confidence, knowing that each frame was being properly exposed. Several rolls of 800 Fuji color negative film were exposed using data obtained from hand held light meter readings. An in-camera meter would give inaccurate readings of the students in their white do-boks (uniforms) that would result in underexposed images. The gym is lit by overhead fluorescent lights. The light tile floor offers some kickback of light for fill, and the uniforms reflect light onto nearby students too.

Figure 4.6 The film was exposed at an ISO of 1200 with a shutter speed of 1/125. The lens opening was set to f/4. The Nikon SB-26 strobe was set on TTL with a minus 2.3 stop correction. Photograph © *The Denver Post*/Barry Staver.

In situations like this, the trick is to get a shutter speed fast enough to stop most of the action, a lens opening that allows ambient fill, and use of the on-camera flash for fill. A beginning photographer would probably use the strobe as the main light source. That would sure stop the action, but the background would go dark, shadows would be strong, and the images would take on the appearance of snapshots—lacking depth and interest.

With the photographic technique in place it was time to capture the best action during the class. The high point and most stressful photographic moment came at the end of class when Grand Master Sereff did a breaking demonstration for the class. Sereff broke concrete roofing tiles using a knife hand strike with his bare hand. The class watches in background as the tiles shatter and fly across the room.

That's a shot you take once and you either have it or too bad. The Grand Master isn't going to break again for a photo op. As he prepared for the break, he didn't ask if the shooter was ready. When he was ready to break, he took a step toward the tiles and smashed through them. In all honesty, the photographer would have preferred the exposure to have occurred a fraction of a second sooner, to capture the hand in the middle of the tiles, with Sereff's eyes opened. This shot, however, shows the intensity needed to perform the feat. The exposure balanced the ambient light from the room so the background didn't go dark. The shutter speed, flash, and photographers timing, froze the pieces of tile and Sereff at the point of impact.

5 Lab Processes

Into everyone's life a little light must fall.

Ancient Tibetan photographer's saying

There is one very important detail your lab must adhere to in order to ensure the quality of low light photographs: the lab must also process the film under low light conditions. Anything more is asking for trouble.

During World War II, Barry's father-in-law developed film in his army helmet while on the battlefield. That's a far cry from the state-of-the-art facilities available today. Although on a few occasions it would not be surprising to discover that the film had been processed in someone's baseball cap around the corner in the alley. Even after all of our experience, we confess that it is somewhat unnerving to hand over film containing precious moments you have spent time and energy capturing to someone else for processing.

To alleviate most of that fear, you should find a lab with a good track record, get acquainted with the owners and operators, and be a repeat customer. Once you see the results you can fine-tune your shooting to match their processing in order to produce optimum quality results. They can help you do a better job of shooting, keep you abreast of changes in film, print, and digital technology, maybe even have the coffee pot on for you after a long shoot. A good lab can often salvage a mistake you have made.

The instruction sheet packaged with film often lists suggested settings for particular lighting conditions and rules of thumb to

follow when shooting. For example: using Brand X film is good in bright sun through light haze; don't shoot back toward the sun; avoid exposures longer than 1/10th of a second; and suggestions such as that. Amateur photographers usually follow these directions to the letter. Many times people complain when their shots won't turn out because it's dark and cloudy outside and they have daylight film in the camera. Feel free to bend or break the manufacturer's suggested guidelines. Great-looking images can often be produced under extreme or unlikely lighting situations. Your lab can work with your underexposed film to print moody images. They can adjust the processing time of film you may have exposed differently than the film box indicated. Color negatives can be printed in black and white, black and white images can be tinted, images can be cropped via custom printing, and you can perform miracles with digital technology.

On His Own Buffalo Nickel

With spare time to kill after an assignment in Bozeman, Montana, Barry Staver took an off-chance drive down a forest service road that produced a most spectacular sight. A herd of buffalo was slowly making its way across a vast meadow. The herd belonged to Ted Turner who lived nearby and had helped to reintroduce the buffalo to Montana.

The sight of the sixty-head herd brought visions of American Indians and frontiersmen to Barry's mind. The herd passed on both sides of his rental car, snorting, chewing the long grass as they slowly moved by, and oblivious to the vehicle. Several photographs were made as the animals turned and headed toward a hillside and the setting sun. Luck was being made this day, not only by stumbling onto the herd but by doing so at the golden hour. Barry could have been in the airport bar, or in the little coffeehouse in Bozeman that makes the best iced coffee anywhere.

Unlike people who can be persuaded to stick around for "just one more shot," the herd of buffalo was heading up and over the hillside. The in-camera meter was providing light readings, with the Nikon N-90s camera set on shutter priority. As the animals became backlit, the metering was switched from matrix to center-weighted. Four frames were exposed as the last animals disappeared over the hill. After the film was processed, it was

Figure 5.1 "Oh give me a home, where the buffalo roam, and the deer and the antelope play . . ." Photograph © Barry Staver.

apparent that the metering had been done incorrectly. A normal print showed detail in the animal and a washed out sky. The center-weighted reading had read the shadow area and given the film additional exposure. A matrix reading would have kept the lens stopped down since it would read more of the sky, but it was too late now.

The selected image was tailor-made to be a silhouette. A conference was held with the color printer, pointing out the need for producing a silhouette. "Not a problem," was their reply. When the print was created, adjustments were made at the enlarger and presto: a majestic animal is seen against a clear, deep blue sky, the way he was envisioned to appear, but not the way he was exposed.

which would have been very distracting and ruined the ambiance of the old school house. Normal processing by the lab would have resulted in underexposed negatives, but labs can adjust the processing of film to compensate for either over- or underexposed film. This can be done to film that is accidentally exposed incorrectly or, as in the case above, when the film is exposed differently on purpose.

For her efforts to educate the students, feed them two hot meals a day, and clean up the school each night, Janice Herbranson earned $6300 per year.

Looking for Mr. Rightlab

Finding a photo lab that meets your standards often feels more like a Las Vegas game of chance rather than part of the photographic process. Here ís a simple check list that can increase your luck.

- First impressions count. Take a look at the price list and promotional material a lab distributes or uses in its advertising. Does it look professional? Does it include all of the information you need to send film to the lab, or will you have to call them to ask questions? The care that goes into the production of every piece of material you see is a direct reflection of the lab management's attitude. If the material looks incomplete or sloppy, how can you trust your precious exposed negatives to them?

- Is the lab easy to do business with? What services are included as a standard way of doing business? If they are a mail-order lab, do they provide prepaid mailers or mailing labels? Does the cost of processing include return postage? All of these costs reflect the hidden cost of working with a lab and make price comparisons difficult.

- Is the lab location convenient? Many photographers do not factor in the cost of travel back and forth when setting their rates to their clients, although they should. Even if you are an amateur photographer, the drive better be worth it in both quality and customer service. Is there a "night drop" outside the lab where you can drop off film after a late-night shoot or on the weekend? A night drop allows you to drop off film when the lab is closed, so it can be processed first thing in the morning. Does the lab offer delivery services? If so, how much does it cost?

Figure 5.1 "Oh give me a home, where the buffalo roam, and the deer and the antelope play . . ." Photograph © Barry Staver.

apparent that the metering had been done incorrectly. A normal print showed detail in the animal and a washed out sky. The center-weighted reading had read the shadow area and given the film additional exposure. A matrix reading would have kept the lens stopped down since it would read more of the sky, but it was too late now.

The selected image was tailor-made to be a silhouette. A conference was held with the color printer, pointing out the need for producing a silhouette. "Not a problem," was their reply. When the print was created, adjustments were made at the enlarger and presto: a majestic animal is seen against a clear, deep blue sky, the way he was envisioned to appear, but not the way he was exposed.

Teach the Children

This image was from Barry Staver's most personally rewarding and favorite assignment by far. The "Lowest Paid Teacher" in America, as uncovered by a National Education Association survey, was Janice Herbranson of McLeod, North Dakota. She taught five elementary school kids in a hundred-year-old, one-room schoolhouse in a small farming town near Fargo. Not only did Janice teach kindergarten through sixth grade, she prepared two hot meals a day for the kids—breakfast and lunch. She was also the school janitor and, to make enough to live on, worked evenings after school tending the small bar in town.

She arrived early each morning, in the dark during the winter, to start cooking a hot breakfast and begin lunch preparation in a small kitchen just off the main classroom. During the morning classes she periodically tended to the lunch being cooked. After school she cleaned the building, sweeping the wooden floor with a broom. In addition to all of her duties, she became adept at the mountains of paperwork needed to obtain grants for the school. One such grant provided a small black and white television so the kids could watch PBS programming from time to time.

Barry spent two days in early February with Janice and the kids. The temperature was 18° below zero, and she sent them outside for recess. Indoors, Barry took off his boots and quietly moved about the small one-room school photographing this wonderful teacher. It only took the kids a couple of hours to accept him and stop looking up every time the shutter clicked. The resulting images were used as the lead "Up Front" story in *People* magazine. The piece was ten pages long and was the first time the magazine had led an issue with a feature—not news—story. The story was told via the photographs and captions alone.

The lighting in the old building was dim, illuminated by bare bulbs hanging from the high tin ceiling. The snow-covered ground and overcast sky blasted white light in through the tall narrow windows. If ever there was a time for black and white film this was it. One roll of color was shot just for comparison, but there was none.

Kodak Tri-X film was rated at an EI of 1200, one and a half stops above its normal 400 ISO. Using this higher exposure index gave the photographs more depth of field, and Barry was able to use faster shutter speeds when shooting. It also made it possible to shoot with available light and eliminated the need for flash,

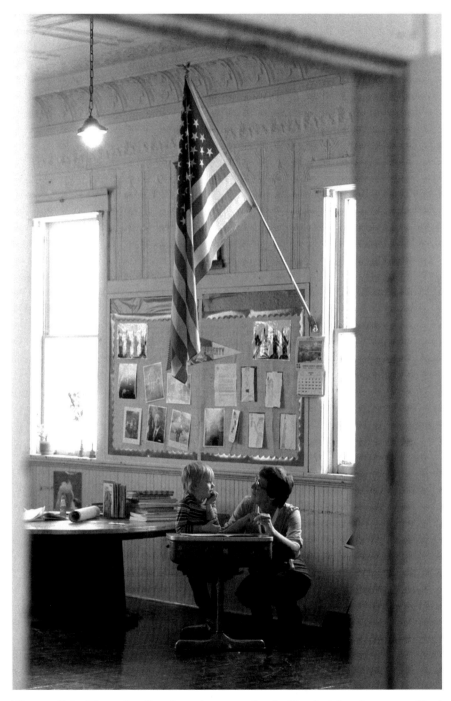

Figure 5.2 The schoolteacher story was basically shot "underexposed" at 1200 ISO. The film was then "push" processed by leaving it in the developer longer. Photograph © Barry Staver.

which would have been very distracting and ruined the ambiance of the old school house. Normal processing by the lab would have resulted in underexposed negatives, but labs can adjust the processing of film to compensate for either over- or underexposed film. This can be done to film that is accidentally exposed incorrectly or, as in the case above, when the film is exposed differently on purpose.

For her efforts to educate the students, feed them two hot meals a day, and clean up the school each night, Janice Herbranson earned $6300 per year.

Looking for Mr. Rightlab

Finding a photo lab that meets your standards often feels more like a Las Vegas game of chance rather than part of the photographic process. Here is a simple check list that can increase your luck.

- First impressions count. Take a look at the price list and promotional material a lab distributes or uses in its advertising. Does it look professional? Does it include all of the information you need to send film to the lab, or will you have to call them to ask questions? The care that goes into the production of every piece of material you see is a direct reflection of the lab management's attitude. If the material looks incomplete or sloppy, how can you trust your precious exposed negatives to them?

- Is the lab easy to do business with? What services are included as a standard way of doing business? If they are a mail-order lab, do they provide prepaid mailers or mailing labels? Does the cost of processing include return postage? All of these costs reflect the hidden cost of working with a lab and make price comparisons difficult.

- Is the lab location convenient? Many photographers do not factor in the cost of travel back and forth when setting their rates to their clients, although they should. Even if you are an amateur photographer, the drive better be worth it in both quality and customer service. Is there a "night drop" outside the lab where you can drop off film after a late-night shoot or on the weekend? A night drop allows you to drop off film when the lab is closed, so it can be processed first thing in the morning. Does the lab offer delivery services? If so, how much does it cost?

- Is the staff courteous and knowledgeable? Too often the lowest paid people in photo labs work at the customer service counter. This is the exact opposite of what should be. The counter people should be pleasant, know the lab's services, and perhaps even greet regular customers by name.

- Do they offer a service commitment for when film or prints will be ready for delivery? Joe Farace dealt with one lab that had a policy that black and white film turned in to them before noon would be processed and proofed by 4:00 P.M. the next day. He went in one morning well before noon with several rolls of exposed 120 film and said "I'll pick them up at 4:00" only to be told that a big order came in ahead of him and if he wanted his film by 4:00 P.M. he would have to pay rush charges! This lab went through several changes of ownership before they finally bit the dust and died.

- A good lab provides complimentary film processing for lighting tests. They will usually require that you include something in the frame that will make the shot unusable, such as a Macbeth color checker, but we find that device to be extremely useful when evaluating exposure and lighting tests anyway.

- How does the lab handle mistakes? No photo lab is perfect and mistakes are going to happen from time to time. What sets a good lab apart from a bad one is what they do when you call it to their attention. The best labs drop everything to fix the problem as fast as is reasonable to expect. Bad labs blame it on "Charlie in the back room." You don't want blame, you want pictures! Joe dealt with one lab, for a short time, where if there were any problems with your order, you were "punished" by making sure that any remakes took longer than the original order and longer than the lab's stated delivery schedule.

- The worst thing you can do as a lab customer is to be a "lab hopper," jumping from lab to lab looking for perfection. Even if the lab makes a mistake or two, hang with them to see how they handle the problem. The longer you stay as a customer, the more likely they will be willing to do you a favor or two when you find yourself in a time crunch or need a little extra help or advice for a certain project.

Give Them a Test

The best way to evaluate a lab is to shoot several rolls of the same kind of film of a noncritical event. Do not try this with

film that you shot at Carleigh's wedding or Max's first birthday party. Then send one roll to each different lab and wait for the results. If you are using mail-order labs, make sure all of the envelopes are dropped in the same mailbox. Make a note of when you sent the film or dropped it off for processing. When you get all the film back, the first test will be who did it in the least time, although that should not be the final basis for selecting a lab. The reason is this: one lab may be faster than the others because they don't care what the final product looks like. But when you are evaluating photo labs, you must keep in mind that famous adage: quality, speed, or price. Pick any two.

Next, analyze the results. When you get the film back from the different labs that you tested, go through the prints, slides, or contact sheets one at a time. Look for how substantial the packaging is. Is it good enough to protect the film in mailing or by normal everyday handling? Look for dents, dings, and rips in the prints or contacts. Make a note of how many prints have exhibited poor handling by the processor or the post office.

Then pick the best two or three prints from the roll and set them aside and mark on the back of the prints, with a Sanford Sharpie pen (which can write on anything), which lab it came from. Next, do the same thing with all of the other rolls of film. Now, mix all of the prints together and place them on a table in the order you like best—taking into account the printing, not just the subject matter. After the photographs are arranged in order, flip them over and see who was the best. To verify your findings, take your stack of test prints and show them to your parents, spouse, and colleagues and ask them what they think the best prints are. This should settle once and for all who is the fairest of them all.

The same procedure can be used with slide film, only arrange the slides on a lightbox for side-by-side comparisons. Another important element to consider when comparing processed slide film is the mounts. This is one place that labs skimp. Do they have high-quality cardboard mounts, wiggle-free Pako plastic mounts, or some cheap imitations of both. Cheap slide mounts are an indication of what the lab thinks of its customers.

The Clip Test

It's OK to bracket your exposures, sometimes. When you are shooting a still life in the studio or a landscape that's not mov-

Figure 5.3 This photograph of Michael Gerding was exposed on a Bronica SQ-A with a 150mm lens. After three to five frames of Gerding holding the globe were shot for the clip test, he then was instructed to start spinning it and several exposures were made. Photograph © Barry Staver.

ing around, go ahead and expose several frames at different settings. That, of course, is what bracketing is all about. When the film is processed, you are able to select the exposure that best suits your needs. Perhaps the one with less exposure gives the look you were trying to achieve. Sometimes the overexposed frames are actually just what you are looking for.

If bracketing is insurance, clip tests are also insurance. Clip tests are much better than bracketing in situations where the

lighting remains constant but the subject does not. Portraiture, executive photo shoots, most photojournalistic work that involves people on the go, are all prime candidates for clip tests. Traditional bracketing of a moving, talking person may see the best expression being lost to a bad exposure. The odds are against you.

Instead of processing an entire roll of film, a lab technician, in the dark, cuts off from one to three frames from either the beginning or end of your designated roll of film and processes it first. The balance of the roll is held back until you look at the clip test and make a decision. The processing can be adjusted in 1/4 stop increments, both over and under, and the entire photo shoot will be usable. In essence, you are bracketing, but at the lab not in the camera. Once the clip test is evaluated, the balance of the film is then processed to achieve the best results. It's easy to do a clip test and not loose one animated, important image. To get ready for a clip test, just be sure to shoot three to five frames at the beginning of the first roll before the photo session begins in earnest, but under identical lighting conditions under which the shoot will occur.

Michael Gerding, one of the best-known global fund managers in the country, was photographed by Barry Staver in front of the firm's headquarters for a national business magazine. He is spinning a plastic globe that, unlike a basketball being spun, did not have enough weight for a lengthy spin. A second or two was the longest the globe would spin before succumbing to gravity. He did not have all day to sit for the portrait, nor was there enough film to do a bracketed photo session. After three to five frames of him holding the globe were exposed for a clip test, he was instructed to start spinning it for the rest of the exposures for the session. A clip test was made, evaluated, and processing was adjusted. This resulted in every frame on every roll being perfectly exposed, and the best spinning image was selected for publication.

A Digital Roller Coaster

The photo lab's traditional role is gradually changing. As digital imaging takes an increasing share in the photographic industry, film and chemical-based printing is declining. We feel that some excessively optimistic predictions that film won't exist by the

year 2000 certainly will not come true, but the fact is that digital imaging is here to stay.

Photographers like Ansel Adams and W. Eugene Smith would spend hours in the darkroom making a single print. Image manipulation using traditional darkroom techniques have been part of the craft of photography since the beginning. Now all of that manipulation is possible on a computer screen using digital imaging techniques. An entire book can be written on the techniques and the ethics of this new-found way to alter images. (Joe Farace's *Digital Imaging: Tips, Tools, and Techniques for Photographers* is also available from Focal Press.) We bring it up here so you will be aware that not only you, but anyone can take your image, as either a slide, negative, or print, and scan it into a digital format. Your photography can then be "opened" onto a computer screen and manipulated in an almost unlimited number of ways.

After Ansel Adams performed his darkroom magic on traditional photographic paper, then developed, fixed, and washed his print, it became his end product. No one else could take the print and alter it unknowingly. It is now possible to take an Adams print, scan it via flatbed scanner and do anything imaginable to it. One could increase or decrease the height of El Capitan or widen Half Dome in his Yosemite photographs. Animals could be "dropped into" the Snake River in his Teton image. Any one of his famous black and white images could be colorized. Digital manipulation can be done at anytime and performed so well that the creator of a work would have trouble recognizing the original image.

That's the downside of digital imaging. This newfound method of manipulating or enhancing an image has many positive aspects. It puts control of the final image back into the hand of the originator. We are no longer restricted to the lab technician's interpretation of color balance or density.

This roller coaster at sunset was one of those "grab shots." It was taken by Barry Staver inside a very small window of opportunity as the sun was momentarily blocked by a small cloud. Only three frames of Kodak Tri-X film were exposed on a Nikon F camera with a 180mm f/2.8 lens. By the time the ride ended, the passengers unloaded, new riders strapped in and started up the coasters incline, the sun had reappeared from behind the cloud, and the moment was gone. The resulting image was a fine silhouette, but it had several power lines running through it

Figure 5.4 For this photograph of a roller coaster, three frames of Kodak Tri-X film were exposed on a Nikon F camera with a 180mm f/2.8 lens. The power lines were removed by using Adobe Photoshop software. Photograph © Barry Staver.

that caused what Barry felt was a distraction. Twenty years after it was made, the negative was scanned using Kodak's Photo CD process. Then, using Adobe Photoshop software, Barry Staver removed the power lines using Photoshop's Rubber Stamp tool to eliminate 90 percent of the power lines, and the eyedropper and paint brush tools for the rest. The new image you see here looks cleaner than the original.

6 Camera Supports

One missed photographic opportunity creates a desire to purchase two additional pieces of equipment.

Dowling's Law

"Sticks" is an old slang term that film and video camera people use for tripods. It came from those days when tripods were made of wood and the legs had sharp points for exterior work. So floors wouldn't be scratched and the tripod wouldn't slide around on its metal points, these cameramen carried an additional wooden brace they laid on the floor when shooting interiors.

Tripods, monopods, and solid surfaces—even your body can be used to support the camera for successful low light shooting. The simple act of placing the camera on a table, chair, rock, and even on the ground will steady it when a tripod is not handy. When you don't have or can't use a tripod, bracing the camera on your body works wonders. While seated cross-legged, you can rest elbows on knees supporting the camera. Standing allows elbows to be tucked into your sides, thus creating a human tripod. Don't think, though, that standing on one leg will enable you to act as a monopod. the stability is just not the same.

Tools of the Trade

The tripod is the most underrated photographic accessory. Yet using one can improve your photographs more than any single photographic tool. A tripod can even be your secret photographic weapon. How?

Some people continue to add lenses and filters to their camera systems, but often wonder why their photographs are not as sharp as they should be. They are probably not using a tripod. Professionals, regardless of their preferred camera format, almost always use a tripod. In addition to providing maximum sharpness, at any shutter speed, the use of a tripod enforces a more deliberate approach to making photographs. Having to think about composition before banging off a few frames can improve the quality of your photographs more than you might imagine. On the other hand, some applications simply demand a tripod.

If you are doing close-up work, a tripod is a necessity. The small lens apertures needed to offset the inherent shallow depth-of-field of macro work have to be compensated by slower shutter speeds. At the other end of the spectrum, using long focal length lenses for sports or wildlife photography requires a tripod—sometimes two. Depending on the focal length, you may need one tripod for the camera body and another to support a long focal length lens. This is a point on which we do not agree, but if you think you do need two tripods, chances are you will find out whether this dual support method suits your photographic style.

A tripod can be a big help in everyday photography. You may think you can hand-hold your camera steady, but this is not always true. An old photographic rule of thumb states that the average person can hand-hold a camera at a shutter speed equal to the reciprocal of the focal length of the lens. Using a 50mm lens yields a minimum hand-held shutter speed of 1/60th. When in doubt, many photographers increase their shutter speed—just in case. Be careful! If you are using a camera with a focal plane shutter, the effective speed of the shutter curtains at 1/1000th of a second, which is really the same as it is at 1/30th of a second. At higher shutter speeds, the only thing that changes a narrowing of the space between the shutter curtains. Under these conditions, an appropriate tripod is not a luxury.

They may seem awkward to carry, but a good tripod protects the investment you have made in expensive optics by delivering the best possible photographs.

Starting the Search

When you stroll into a camera store and are confronted by a forest of tripods growing out of the floor, you need to be able to

analyze the choices that you face. There are many kinds of tripods available, and picking the right one is not always easy. Like camera lenses, different tripods have specific applications. You may even find that you need more than one. What is most important is finding a tripod that fits the type of photography you do.

Let's face it, a tripod has a very simple job. It has to eliminate vibration and hold your camera steady. How this is accomplished is the basis of all differences between types and brands of tripods. The first rule to keep in mind while tripod shopping is: beware of bargains. Tripods come in a variety of prices, but you generally get what you pay for. You may be tempted to cut corners with your first purchase. Don't do it! When Joe realized that he could hold a camera steadier than his first tripod, he threw it out. The tripod's head wore out because I ignored the first basic question you should ask yourself: what kind of camera am I planning on using with this tripod? I was using a medium format camera on a tripod that would have given me better service with a 35mm camera. The additional weight of the camera was too much for the head and it wore out prematurely.

Be careful not to overcompensate. A tripod designed for a medium format camera has to be physically larger and heavier than one designed for 35mm use. If you plan on using your new tripod (mostly) with a small format camera, you could end up lugging around more weight than you want. The kind of camera you use also affects the type of legs and tripod head that will be right for you.

Legs and Feet

There are three different types of tripod legs. The tubular style is strongest because a metal wall completely surrounds the leg. It's the type you will see on most professional tripods. The U-Channel leg design, to some, may appear more attractive, but the leg's open side doesn't provide much structural rigidity. The leg itself is weaker and more easily twisted. Some tripods use a leg that's closed on all sides for strength, but retains the aesthetics of the U-channel leg.

The type of legs determines the type of leg lock. Round legs generally have threaded collets that can always be tightened

Take the Elevator

The purpose of the center column (or elevator) is to raise or lower the camera's height. The most common elevator is the lift type that uses friction and the photographer's arms to raise and lower it. The locking function is provided by either a screw or collet system. Almost as popular is the crank and gear type. When the crank is rotated, a gear is turned, which raises or lowers the center column. This system provides precision in raising or lowering the column, but is usually slower than the lift type. Check to see that the gear teeth are sturdy enough for your camera's weight and the type of photography you will be doing.

Some professional tripods use a clutch system, which provides a combination of lift and crank and gear types. The center column is unlocked by depressing a spring lever that's automatically locked when the lever is released. In addition to center column types, some kind of friction control is important. If you have ever had a center column—with camera—come crashing down, you know what we mean. The tripod should have some type of column control that adjusts to the weight of the camera so that the camera will remain balanced—even when unlocked.

When it's all over, the choice is yours. There are, however, some points to remember when searching for a tripod. A good tripod is expensive. Industry sources tell us that 90 percent of the sales of top-of-the-line tripods are to photographers who are unsatisfied with the quality of their old tripod. When considering what kind of head or legs you need, remember that camera stores typically sell an equal number of ball vs. pan-tilt heads—it's a matter of personal preference. Check the tripod's construction. Does it lend itself to simple and inexpensive repairs? All of these factors add up to a tripod that will give years of satisfaction, and improve your photography, all at the same time. And that's not a bad combination.

Monopods

When you think about it, the concept of a monopod is kind of funny. After all, they are nothing but one-legged tripods! While that may seem like a contradiction in terms, it might be the kind of camera support you are looking for.

If you photograph sports events, a monopod can be an excellent support for the long lenses you use. For the occasional sports

analyze the choices that you face. There are many kinds of tripods available, and picking the right one is not always easy. Like camera lenses, different tripods have specific applications. You may even find that you need more than one. What is most important is finding a tripod that fits the type of photography you do.

Let's face it, a tripod has a very simple job. It has to eliminate vibration and hold your camera steady. How this is accomplished is the basis of all differences between types and brands of tripods. The first rule to keep in mind while tripod shopping is: beware of bargains. Tripods come in a variety of prices, but you generally get what you pay for. You may be tempted to cut corners with your first purchase. Don't do it! When Joe realized that he could hold a camera steadier than his first tripod, he threw it out. The tripod's head wore out because I ignored the first basic question you should ask yourself: what kind of camera am I planning on using with this tripod? I was using a medium format camera on a tripod that would have given me better service with a 35mm camera. The additional weight of the camera was too much for the head and it wore out prematurely.

Be careful not to overcompensate. A tripod designed for a medium format camera has to be physically larger and heavier than one designed for 35mm use. If you plan on using your new tripod (mostly) with a small format camera, you could end up lugging around more weight than you want. The kind of camera you use also affects the type of legs and tripod head that will be right for you.

Legs and Feet

There are three different types of tripod legs. The tubular style is strongest because a metal wall completely surrounds the leg. It's the type you will see on most professional tripods. The U-Channel leg design, to some, may appear more attractive, but the leg's open side doesn't provide much structural rigidity. The leg itself is weaker and more easily twisted. Some tripods use a leg that's closed on all sides for strength, but retains the aesthetics of the U-channel leg.

The type of legs determines the type of leg lock. Round legs generally have threaded collets that can always be tightened

enough to lock the legs in place. Tripods with U-channel legs typically have locking levers. These levers are easy to use, but they tend to wear out faster. While most tripods use these two basic types of leg locks, there are variations. Some tripods also feature leg braces that extend from the center column to each leg. This type of construction prevents the legs from closing when you don't want them to. While these braces make the tripod slightly heavier and difficult to fold quickly, they add considerably to overall rigidity.

While tripods (usually) only have three legs, the legs themselves come in a choice of the number of sections. A tripod with three, or less, sections will be stronger and less expensive to build. If you are looking for something to take backpacking, tripods with four, or more, sections may appeal to you. This kind of tripod may be compact, but will not be as rigid for general-purpose photography. If you do more than one type of photography, you may need more that one type of tripod.

There are as many different types of tripods for your camera as there are athletic shoes for your feet. The most basic foot is the crutch tip, which is a rubber cup that prevents the metal legs from scratching the floor. Some brands of tripods feature a rubber tip for wooden and other slippery surfaces, plus a retractable spike for outdoor use.

Heads

Some manufacturers offer a choice of leg and head types allowing you to mix and match to find the best combination for your needs. You may even want to use one manufacturer's tripod head on another manufacturer's legs. Joe Farace's first really good tripod used a Gitzo head on a set of Davis and Sanford legs. Over twenty years later, he still has both components, although the Gitzo head is now attached to a set of Gitzo legs.

You will find two general types of tripod heads: ball or pan-tilt. To determine what kind of head you want, take a look at the size of the head. It may not be obvious to the novice tripod shoppers, but the size of the camera platform on whatever head you want to use should be appropriate for the size of the camera. The larger the platform, the more securely the camera can be seated and balanced. A larger head also provides the space for positive-locking mechanisms.

While there may be some disagreement among photographers as to which are the best kind of tripod legs, there is quite a debate as to what type of head is "right." On one side, there are the ball-head aficionados; on the other are their opponents, the pan-tilt head team. The ball-head folks will tell you (loudly) that their favorite is "quick, easy to use, and you don't have to turn different levers to get it where you want." The pan-tilt head group, on the other hand, will tell you that "it's easier to level the camera, or follow movement, plus it's faster to set up."

Ball heads are more compact and feature only one control (they said it was simple). That single control is a knob, or lever, that locks and unlocks the ball mounted under the camera platform. By unlocking the ball, the photographer can move the camera freely and easily in any direction. When tripod hunting, keep an open mind. Ask yourself how it feels. Is it easy to use? When many people are exposed to a ball head for the first time they say, "Wow, I love it." The point is that you will never know until you try.

If you are a more traditional photographer, you may feel more comfortable with a pan-tilt head. They usually have three levers, or sometimes two, that control forward and backward motion, plus the ability to quickly change from horizontal to vertical position. Most two-lever models require you to reorient the camera on the platform for vertical or horizontal photographs. Unless you are shooting a square format camera, a three-lever model will be less of a hassle in the long run. Some two-lever models provide three-lever flexibility by using a small lever that provides for this flipping action. Each movement of a pan-head requires a means of locking that movement. While this may be slower than a ball head, it usually provides an easier method for leveling. Unlike a ball head, one axis can be adjusted at a time. This can be especially important if you're doing precise composition, such as architectural photography.

One interesting accessory that's built into some tripod heads is a QR, or quick release. This feature allows the camera to be quickly removed without unscrewing the camera from the tripod's platform. This is usually accomplished by threading a device into the base of the camera that fits into a hole in the platform. For the photographer who has to change cameras quickly, this feature might be important. All you need is one of these QR devices pre-threaded into each of the bodies that you will be using during any particular photo session. (See Figure 6.1 in color insert.)

Take the Elevator

The purpose of the center column (or elevator) is to raise or lower the camera's height. The most common elevator is the lift type that uses friction and the photographer's arms to raise and lower it. The locking function is provided by either a screw or collet system. Almost as popular is the crank and gear type. When the crank is rotated, a gear is turned, which raises or lowers the center column. This system provides precision in raising or lowering the column, but is usually slower than the lift type. Check to see that the gear teeth are sturdy enough for your camera's weight and the type of photography you will be doing.

Some professional tripods use a clutch system, which provides a combination of lift and crank and gear types. The center column is unlocked by depressing a spring lever that's automatically locked when the lever is released. In addition to center column types, some kind of friction control is important. If you have ever had a center column—with camera—come crashing down, you know what we mean. The tripod should have some type of column control that adjusts to the weight of the camera so that the camera will remain balanced—even when unlocked.

When it's all over, the choice is yours. There are, however, some points to remember when searching for a tripod. A good tripod is expensive. Industry sources tell us that 90 percent of the sales of top-of-the-line tripods are to photographers who are unsatisfied with the quality of their old tripod. When considering what kind of head or legs you need, remember that camera stores typically sell an equal number of ball vs. pan-tilt heads—it's a matter of personal preference. Check the tripod's construction. Does it lend itself to simple and inexpensive repairs? All of these factors add up to a tripod that will give years of satisfaction, and improve your photography, all at the same time. And that's not a bad combination.

Monopods

When you think about it, the concept of a monopod is kind of funny. After all, they are nothing but one-legged tripods! While that may seem like a contradiction in terms, it might be the kind of camera support you are looking for.

If you photograph sports events, a monopod can be an excellent support for the long lenses you use. For the occasional sports

photography Joe Farace shoots, it is not always possible to get a sidelines pass. If you have ever been stuck photographing from the stands, you know there isn't much space in which to work. A tripod can interfere with the other spectators, and that won't create the kind of environment that will help you get your job done. A monopod won't create those kinds of problems. You will be able to make your photographs *and* get along with the people you are sitting with.

You don't have to be at the Olympics or a Denver Broncos game to find yourself in a crowd; many political or entertainment-oriented affairs often have designated areas for the press to work from. Some spot news events also generate wall-to-wall people that will make you appreciate the space-efficient monopod. If you need to shoot over people's heads, use the monopod to raise your camera and trip the shutter with a long cable release.

For those situations where space and weight is at a premium—like nature and wildlife photography—the monopod is ideal. With space at a premium for the backpacking photographer, the monopod is ideal because of its compactness and light weight. The weight is one-third of a tripod of similar quality.

Tip from Barry: On Using Monopods

In journalistic work, a monopod is used more often than a tripod. They are easier to move about with, set up quicker, and break down faster. A monopod lets you make 1/2-second exposures with 80mm and wider lenses, and 1/60th exposures with lenses up to 300mm. Most monopods, when extended to their full length, tend to flex slightly at their joints. To maintain maximum rigidity, don't completely extend the monopod. Leave approximately two inches of one leg *inside* the next larger tube. This will result in a stronger, more useful (though somewhat shorter) camera support. Gitzo's smaller, multisection monopods have been designed to take this fact into consideration. Monopods are available from most of the major tripod manufacturers, including Bogen/Manfrotto, Cullman, Linhof, and Gitzo.

In general, monopods can be used with the same heads used by tripods, but they're typically used without any head at all. The 1/4-20 threaded bolt sticking out from the top of most monopods can be screwed into the bottom of your camera or the

tripod collar included with many long focal length lenses. You will find that most heads get in the way when using a monopod. Unlike a tripod, monopods can be easily moved side to side to get the precise camera angle you want.

And Now for Something Completely Different

All tripods have a similar function: they hold your camera steadier than you can. Most accomplish this by using a design that follows what we have covered up to now. One tripod brand that deserves special mention is Benbo. Because it has three legs it looks like a tripod, but any resemblance ends there. Let's start with the center column: Benbo thinks of it as a "monorail" that allows you to place your camera precisely after the legs are set. The monorail can be set not only up and down, but also vertically, horizontally, and at any possible angle in between—without cranking any gears. The legs sections overlap the upper sections and have tightly sealed end caps that enable you to set the legs in a stream or mud, or whatever it takes to get your camera where you want it to be. The legs also spread wide, something that some Gitzo tripods do as well, to get the tripod close to the ground, allowing you to make macro shots. As you can tell by the illustration, the Benbo is the ideal tripod for the adventurous photographer.

Mormon Temple at Christmas

The combination of low light requiring a time exposure and a cold winter night provides an ideal situation for using a tripod. Chattering teeth tend to add unwanted camera movement that would only be acceptable in an art photo. While it is possible for some photographers to hand-hold a camera for 1/8th- and even 1/4-second exposures, anything longer requires even the steadiest hand to shift to a more solid camera support. (The 1/8th- and 1/4-second exposures should only be done if you are using a normal to wide angle lens.)

The photograph of the Mormon Temple in Salt Lake City was commissioned by *Time* magazine for a story on Christmas lighting. The Temple itself is not illuminated with lights like Denver's City and County Building, which we saw in Chapter 2. Only the adjacent courtyard has lighting in the trees. It was hard to scout

Figure 6.2 The Benbo family of tripods is designed to enable photographers to place their cameras in places that might otherwise seem impossible. Think we're kidding? Just take a look. Photograph courtesy The Saunders Group.

the area for the best vantage point during the daylight. There was no way to tell how bright the various areas of the courtyard would be. A nearby hotel offered a vantage point that looked promising and an appointment was made with the general manager to acquire permission to photograph from the property.

The hotel was glad to be of service and suggested their top floor restaurant or the rooftop as vantage points. Over the years Barry Staver has learned that most nonphotographers do not have a clue about photographic angles and positions. The uneducated often suggest the highest landmark as the ideal photo spot. Talk of aerial photographs to show the "wide view" are often heard. In most cases, the highest spot around does *not* provide the best photographic vantage point. If you get too high, you will only see adjacent rooftops that have air conditioning units and assorted ductwork. Images shot from helicopters and fixed wing aircraft get the photographer too far away from the action and show nothing but rooftops.

The hotel restaurant windows turned out to be too far back and provided an oblique angle of the Temple. The rooftop was too high, as the courtyard below was lost and the camera tilt would make the Temple look grotesque. The manager then understood the need for a better shooting spot and offered any hotel room that faced the Temple that was not already occupied. The location scouting went on for another hour until the best room was pinpointed. It appeared that the sunset would be good and would provide an additional lighting element to the scene. (See Figure 6.3a in color insert.)

Two cameras were positioned on two separate tripods, since this photograph was being taken on a deadline and there would be no second chance. An interesting and exciting image was required in the Time-Life Building in New York the next day. Many magazines still prefer film to digital transmissions so, more often than not, unprocessed film is shipped counter-to-counter via an airline. The photographer takes the film to the airport where it's put on the next flight. A courier is hired to receive it at the New York airport and expedite it to the Time-Life photo lab.

Several rolls of daylight-balanced and one additional roll of tungsten-balanced Ektachrome were exposed for this assignment. Bracketing was used extensively and the framing of the image was changed as well. Both vertical and horizontal images were shot. The tripods were old and one was even borrowed. As long as the legs and the head lock into place, looks don't matter. After the sunset, additional photographs were taken from the

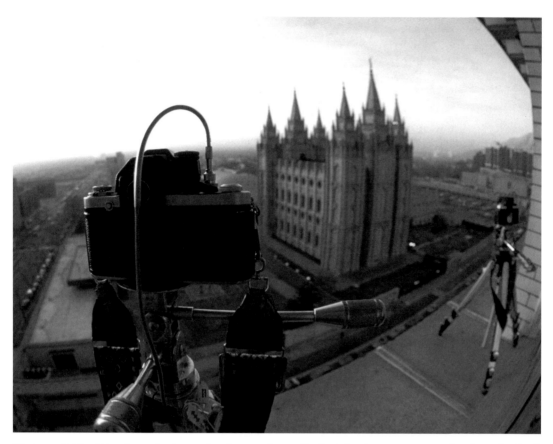

Figure 6.3b Here's a photographer's-eye-view of what the Mormon Temple shoot looked like out the window. Photograph © Barry Staver.

Temple courtyard with the lights in the foreground and the large building as background, but they did not convey the scene as well as the image made from the hotel window.

The Historic Brown Palace

Many low light situations require a camera support, but using a tripod in some poorly lit situations isn't always practical and sometimes is not allowed. Fortunately, there are ways to solidify your camera without depending on the traditional "sticks."

The Brown Palace is Denver's landmark downtown hostelry. It has been home to Presidents, royalty, and dignitaries of all kinds. At Christmas time its interior is illuminated with an enormous chandelier that hangs high above the lobby. A holiday tra-

dition has been for the city's debutantes to be presented to society in this festive lobby setting. At this time, the lobby and hallways are filled with partygoers who are not paying attention to tripods or any other photographic paraphernalia lying about. If you are not careful, broken legs and broken cameras could result in financially broken photographers.

Barry Staver's assignment for *Modern Maturity*, the magazine with the highest circulation in the United States, was to capture the splendor of this event. The editors envisioned using the photograph as a double truck—one photograph covering two adjoining pages—the following year. They were adamant about the scene being photographed with nothing less than a 4x5 camera. (See Figure 6.4 in color insert.)

Location scouting and logistics discussions were held with hotel representatives the day before the Debutante Ball, after the lighting and decorations were in place. Tripods and additional photographic lighting would not be allowed due to the size of the crowd. All positions along the balcony railing were reserved by the families of the debutantes, and the hotel did not want those people disturbed by "bothersome photographers." Several sheets of 4x5 Ektachrome were exposed to check the lighting. An exposure of 1/2 second at f/4 was required to get an acceptable image on tungsten balanced film, pushed one stop.

This Nikkor 65mm f/4 SW lens was the only one that was fast enough and wide enough to capture the low light scene. Barry brought a six-foot wooden ladder to the event and mounted the camera to a Sinar clamp that held the 4x5 camera rail to the top of the ladder. The clamp is used three to four times a year to hold cameras to other ladders and railings when a tripod is not practical. This position put the camera above the debutante families along the railing, allowing them to be included in the shot. It framed the image below quite nicely. Because of its size, the ladder was less of a hazard than a tripod—even drunken socialites could navigate around it. The only problem was that partygoers kept putting their empty cocktail glasses on the ladder's steps and two or three were knocked off and broken. This turned out to be a small price to pay for an image that is still being shown in Barry Staver's portfolio.

Postscript: A side note about how the image eventually appeared in the magazine is one that photographers who shoot for publications encounter all too often. The magazine did publish the photograph the next holiday season, but instead of a

double truck image, it ran about three by two and a half inches in size. It could have been shot with a 110 camera.

Venus de Milo

Some locations do not permit the use of tripods. Many museums and galleries prohibit tripods because the public spaces are too crowded and camera supports could become a hazard. People would be tripping over the dozens of sets of sticks, falling and breaking up priceless works of art. (Some art should be broken up and tossed out, but that's another story.)

Because priceless art masterworks need protection from extraneous light, the use of flash is also prohibited in most museums and galleries. There are very simple solutions that will let you get great low light photographs while observing these museum restrictions.

First, use high speed film. There are many choices in color negative and transparency film from which to choose.

Second, use your body as a "tripod" by supporting the camera and holding very still. You can tuck the elbows into your sides providing additional support for the camera. Release the shutter as you slowly exhale. Do not hold your breath and fire the camera.

Third, if you cannot turn the flash off on your camera, put some dark tape over the flash and cover it completely. When you fire the camera, the automatic flash will go off, but the tape covering will keep the light from being dispersed. That's better than the embarrassment of being thrown out of the museum.

Lastly, if you have a tripod with you, check with the museum management office about getting permission to use it. If you apply the day before and agree to abide by the museum's rules, tripod permits sometimes will be issued for a modest fee. If you have the time, try this alternative.

Climber in Fog

It's good advice to bring your camera along when you go on outings, since you never know when a great photographic opportunity will present itself. It's not always possible or practical, however, to bring a proper camera support along when climbing through a wilderness trail. Most of us would also not consider

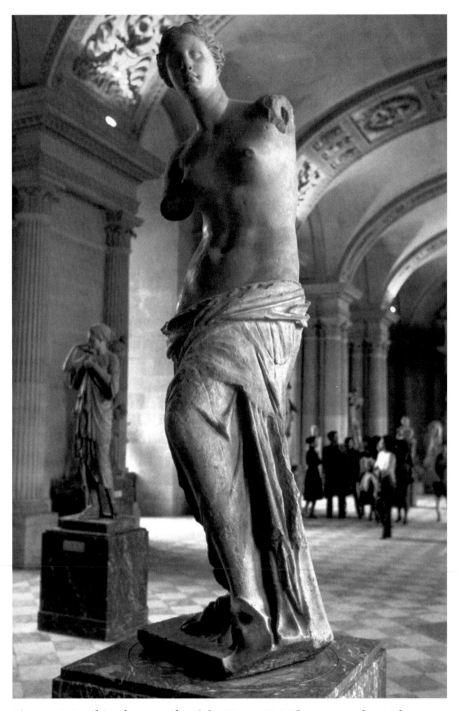

Figure 6.5 This photograph of the Venus DeMilo was made at The Louvre in Paris. The people in the background help add scale to the scene. The camera was hand-held by bracing the arms in against the body and slowly releasing the shutter while breathing out. Photograph © Barry Staver.

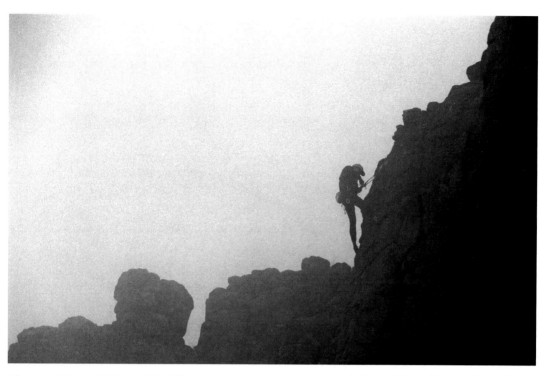

Figure 6.6 A 300mm f/4 Nikon lens was rested on a four-foot tall boulder at the edge of the trail. The photographer knelt down beside the boulder, resting the lens hood on the rock, and easily shot 1/30th second exposures with the long lens. Photograph © *The Denver Post*/Barry Staver.

strapping a tripod to the back of our bicycles before an afternoon ride or slinging one over our shoulders before a mountain hike, but a camera neatly fits into a travel pouch or a fanny pack.

There are dozens of supports all around us that will make excellent camera supports for longer exposures in low light: rocks, trees, picnic tables, backpacks, desks, tables, chairs, floors, car hoods, truck fenders, vehicle window frames, countertops, bar tops, bar stools, work benches, ladders, camera bags, suitcases, or stacks of books or magazines, to name a few. We have used any and all of these as impromptu camera supports.

Wherever you choose to place your camera, be careful not to mar a delicate surface with it. Before setting equipment on antique furniture or the hoods, fenders, and trunks of expensive vehicles, put a towel, a handkerchief, or any sort of padding under the camera to protect the finish of the improvised camera support.

Once you begin to pick out these supporting surfaces, aiming the cameras becomes the next concern. Depending on where you have chosen to rest your camera, it may be difficult to see through the viewfinder as you are normally accustomed to doing. In fact, it may be so difficult that you will have to estimate the framing and composition. In which case, it's better not to crop too tightly rather than to cut off a person's head or a mountain top.

Once the camera is stabilized on your makeshift tripod, the shutter can be released normally by hand. Should you require a finer touch, use the self-timer function on the camera. One additional step for eliminating any chance of camera movement with single lens reflex cameras is to lock the mirror up, then activate the self-timer.

The climber in fog was taken while Barry Staver was hiking along a popular trail near Golden, Colorado. The trail was steep and windy. Instead of lugging his two usual camera bodies, Barry carried just one. Extra lenses were placed into a fanny pack along with water and a poncho. Late afternoon storms are common in the area. Instead of the usual thunder and rain, however, fog rolled in, blocking the late afternoon sun. The scene provided a good photographic possibility and Barry was there ready to capture it on film.

Who Shot JR? Barry Did!

Your body can be used as a camera support, too. It is possible to steady a camera in many ways, enabling low light photography when other supports are not handy. If you are in a room and there is no table or chair or bookcase to rest the camera on, then hand holding becomes the *only* way to support the camera. Here is a situation where "body language" takes on a whole new meaning. When you find yourself in this situation, you want to be in body positions that are solid yet not so rigid that tensed muscles cause the camera to shake.

A tripod isn't used with its legs kept together under the head, and neither should your body. Just spreading the feet apart ten inches to two feet will add a lot of stability to you as a camera support. Holding the camera in both hands with elbows dangling down isn't supportive, but tensing the muscles in your hands and arms to compensate doesn't help either. During a long exposure, tightened muscles will cause your camera to

Figure 6.7 The "Who shot JR" image was shot on Kodachrome 64 film with the photographer in a kneeling position holding his Nikon cameras. Two different camera bodies were used as insurance against a possible problem or equipment failure. Photograph © Barry Staver.

shake. Relax your arm muscles and tuck the elbows into your sides. Let them rest against your abdomen or sides with relaxed arm muscles. This position will provide better support for slow shutter speeds.

Leaning against a solid object will add even more stability to your body. A wall or pillar in a building, or a tree or large boulder outside are examples of solid objects. A large cactus plant or office cubicle partition are probably not good supports. The simple act of sitting down will be more stable than standing up to shoot. Sitting in the middle of the street as the bulls run in Pamplona, Spain may not be the best place to try this advice. It is better to risk camera movement while standing than to view sharp images from a hospital bed after being gored by a bull.

Sitting and leaning against a solid object increases the stability of either of these actions performed alone. Sitting cross-legged with elbows resting on the knees actually looks like a tripod configuration and is quite secure. In all of the above cases, it is imperative to relax as you depress the shutter. Breath out lightly as you push the button. Holding one's breath will only increase the tension and increase the likelihood of camera shake.

Barry Staver really needed bodily camera support for this *People* magazine cover photograph of actor Larry Hagman. The actor was in character as JR Ewing from the hit television series *Dallas*. Filming was being done on location in Dallas for the first fall episode in which viewers would discover "who shot JR?" in the last episode of the previous season. Mr. Hagman's character had been shot and hospitalized. This scene took place as he sat in a wheelchair in a hospital. The actual setting for the scene was the glass atrium swimming pool area of a Dallas hotel. The scene was shot in June, with the outside temperature over 100°. The temperature and humidity inside were stifling, and the addition of television lighting didn't help the situation much.

This illustration represents the two-minute "cover photo" session that was permitted by Mr. Hagman. At the conclusion of the scene, the director invited the photographer in to get the shot. Fortunately, the lighting director kept the daylight balanced hot lights on for fill. In two minutes, Barry chased half a dozen extras and crew from behind the wheelchair. He then positioned the wheelchair and Hagman so they covered up a heavy concrete trash can in the background. Then he moved several chairs and plants from the background. Getting ready for the shot, Barry took an incident light reading with his hand-held meter. He asked Mr. Hagman to sit in the wheelchair, angling the chair slightly.

Sheer panic and anxiety caused the camera to shake. The image was shot on Kodachrome 64 film, known for its sharp-

ness (magazine covers need to be tack sharp) and there was no time to deal with a tripod. Standing provided the wrong angle for a seated portrait. Sitting on the ground was too low, but kneeling was just right. The most stable position when kneeling is to put one knee on the ground underneath you, leaning the body forward resting the elbow on the thigh of the other leg that's out in front of you. The camera was cradled in a vertical position in the palm of the left hand. Under these conditions, Barry shot between twenty and twenty-five frames on two pre-loaded Nikon cameras. In this case, as in other similar critical shoots, two different cameras are used as insurance. Should a problem develop with one, the other will have captured the needed image. After the exposures were made, the actor got up and walked off the set. Finis.

The Lone Runner

Shadows can ruin a photograph. Haven't you ever cringed when looking at portraits that were taken around midday and feature horrible dark spots where eyes should be? You have seen the group shot where taller folks cast shadows on their shorter neighbors. Then there are the photographs taken with the sun directly behind the subject, with no additional fill light. In this case no detail is provided on the negative or transparency and you see a silhouette—usually unintended. The rules of photography *are* made to be broken, or bent a little for sure. In many cases a shadow can actually add to or make the photograph and shooting into the sun *can* produce exciting images.

Probably 98 percent of photographs are taken at the eye level of an upright adult. Cameras, then, are positioned anywhere from five to six feet—give or take an inch or two. This camera angle provides a very limiting point of view. Some of the selling points for the use of tripods include the fully extended height and the leg spread feature that puts you at its lowest shooting position. Most tripods never see action at either end of these extremes. They are used at mid-height, our eye level. One good feature of the old Kodak box cameras and the twin lens reflex was its waist-level viewfinder. America's shooting angle was then at about chest level. Many great photographs, however, have resulted in extra laundry bills for the photographers because they were lying on the ground while shooting. Acro-

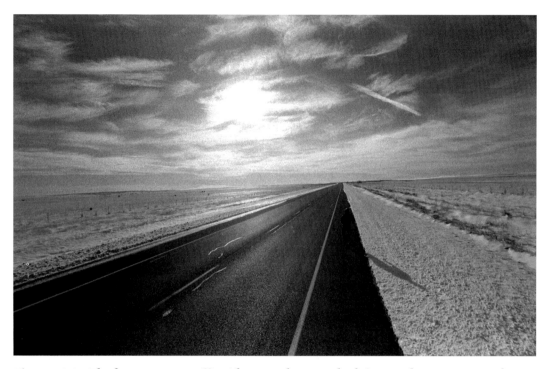

Figure 6.8 The lone runner, Jeff Keith, was photographed for *People* magazine with a Nikon camera equipped with a 24mm lens and Kodak Tri-X film. Photograph © Barry Staver.

phobiacs (like Joe) don't need the additional stress incurred by shooting from high points, but other photographers can get marvelous images when shooting from a high angle.

This illustration bent both unwritten rules of photography. It was taken directly into the late afternoon sun and it was shot from on top of a moving motor home. Amputee Jeff Keith was well on his way to completing his cross-country run of America. He started in Boston, finished in Los Angeles, and was photographed by Barry Staver for *People* magazine, in the high desert of New Mexico. His routine was to run eight miles each day, four in the morning and four more in the afternoon. As Keith ran along the shoulders of our nation's highways, a motor home followed him, acting as a support vehicle and providing a safety buffer from passing motorists. The rooftop of the motor home raised the camera angle five or six feet, enough to enhance the image considerably. The long shadow trailing Keith is more visible and the road in the foreground is larger, emphasizing the

solitude of his journey. The wide angle lens captures the expanse of the land and gives the viewer a perspective of a never-ending road. The camera was steadied by laying flat on the mobile home's roof using the elbows as braces, much like tripod legs. The temptation for Barry to photograph the runner from inside the heated motor home was great, but the effort required to shoot from atop the cold roof in winter against the wind chill from the vehicle movement paid off.

7 Low Light Accessories

Zipf's Law: You tend to place nearby the tools you use most often.

George Kingsley Zipf

Every photographer has his or her own favorite accessories that they use for specific situations and we're no exception. In this chapter we will share with you our favorite gadgets, gimmicks, and accessories that we would never leave home without.

Filters

Fluorescent lighting is efficient, inexpensive, and widely used, but it is a nightmare for photographers working in color. These ubiquitous tubes come in a wide variety of color temperatures ranging from 4200 to 6000° K. As the tubes age, they also change color temperature. These light sources produce a horrible green light that is not easily seen by our eyes yet is picked up quite easily on film.

An architectural photographer that needs complete color correction in his interior photographs spends a lot of time correcting for these fluorescent tubes. As we discussed in Chapter 1, a color temperature meter can be used to check these "green" light sources and, along with a filter kit containing dozens of color-correction filters, can be used to get the green out. Some photographers will even put individual magenta-colored gels, from companies such as Rosco, around all of the light tubes illuminating the scene.

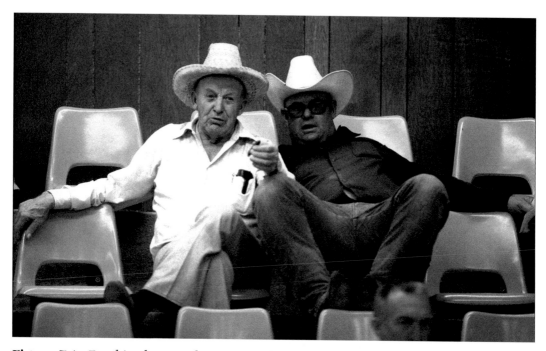

Figure 7.1 For this photograph, an FL-D filter was placed in the filter holder of a Nikon 300mm f/2.8 lens. The camera and lens were supported by a monopod for this low light exposure. Photograph © Barry Staver.

For most editorial photography, an FL-D (fluorescent day-light) filter will suffice when used with daylight balanced film. FL-B filters, which are designed to work with tungsten-balanced film, are available from companies such as Tiffen. The FL-D is a magenta-colored filter that, when placed over a lens, offsets the green cast produced in most fluorescent lighting situations. Be aware, however, of the trade-offs involved with using any filter. All filters have a "filter factor" that requires additional exposure on the film. While the in-camera meter will compensate for the filter, you could also use a stop or two of additional shutter speed, aperture, or both.

The FL-D filter works fine until additional extraneous light sources are introduced into the scene. If window light should be included in the scene, the area illuminated by daylight will become magenta on your film. If you use a flash in this situation its areas of illumination, too, will become magenta in color. A secondary correction can eliminate this. By placing green gels over daylight sources in combination with the magenta filter on the lens, everything will balance to daylight. That may sound like a great solution, but we did not take into account the loss of

light through not only the magenta on-camera filter but also the green filtration of the light sources.

It can become tricky indeed to properly handle the green light from fluorescent tubes. The "good ol' boys" shown in the illustration are ranchers at a cattle auction in Brush, Colorado. They are sitting in the small auction barn checking out the day's offering of cattle, unaware that they are photographic subjects, too. The entire barn was lit by fluorescent tubes. An FL-D filter was placed in the small 39mm filter holder of a Nikon 300mm f/2.8 lens. The camera and lens were supported by a monopod for this low light exposure.

Even More Filters

Unlike Joe Farace who has always loved working with filters, Barry Staver seldom uses filters—unless he has to.

The photograph of the sun framed by electric wires was taken for a utility company's annual report cover. (See Figure 7.2 in color insert.) The concept behind the cover image was to combine traditional energy and newer, experimental types of energy sources. For Barry, it was nice to have an assignment that involved conceptualizing without art directors or clients looking over his shoulder. The obvious photograph would involve the sun and existing electric lines. Hours of scouting time went into the location site. Most electric poles and wires had obstructing backgrounds near the horizon line where the sun would come up, or they were high enough in the air that a sunrise shot was not possible. The perfect site was found just out of the metropolitan Denver area where construction had not overtaken farm land. One electric pole had a clear backdrop to the horizon, and the wires and insulator were framed perfectly from the roof of the car. Fortunately, it was an old International Scout with a solid roof.

The photograph needed to be bold and distinctive, and the wires and sun needed to be large in the frame. To accomplish this effect, a Nikon camera was tripod-mounted. On it, a 600mm f/4 lens was used with a 1.6 teleconverter attached to provide an effective focal length of 960mm. For added color, an orange filter was placed in the 39mm filter holder of the lens.

The first three day's shooting at the site were futile. Either small clouds or wind kept the photo shoot from being a success. A lens of that magnification could not produce a sharp image

while tripoded on a car roof in a strong wind. The fourth day was cloudless and calm. Exposures were bracketed as the ball of sunshine rose behind the electric apparatus. Initial focusing was done on the wires before the sun came into the camera view. Barry's eyes even teared up due to the brightness of the magnified sun passing through the lens and viewfinder.

Know Where to Hold 'Em

As you can see from the above adventures, as well as the mixed light experiences described in Chapter 1, filters can be one of the available light photographer's most useful accessories. You can always toss your filters in a pocket of your camera bag, but using a filter case or "wallet" to store them is even a better idea. Joe Farace uses an old Nikon filter case to hold six of his most often used 52mm screw-mount filters, but companies such as Domke and Tiffen make similar filter wallets.

In Joe's case you will find the following in his basic available light package of filters: a Tiffen FL-D fluorescent filter for daylight balanced film; a Tiffen 85 filter for converting tungsten film to daylight, or just to kick up a sunset a notch; a Nikon A2 "warming" filter to add warmth to an otherwise coolly lit scene; a Tiffen 80B filter for converting daylight film for use under 3200° K (tungsten) lighting; and a Tiffen 30M, the classic color-correction filter for fluorescent lighting. You will also find a Nikon R60 (25A) deep red filter that Joe uses for his infrared photography.

All of the slots that hold the filters are labeled by type—he is the Felix Unger of photography—so that the correct filter is placed back into the correct slot. The filter case and six filters folds into a compact package that easily fits anywhere in a camera bag or jacket or vest pocket. Don't leave your home or office without your own available light filter kit.

Ecological Filters

Photographers like Joe spend a lot of money on filters. Among the hundreds from which to choose there are filters that do everything from changing colors to adding starburst effects to highlights.

Figure 7.3 This forest service firefighter is battling a major blaze in the Boise National Forest in Idaho. Photograph © Barry Staver.

Mother Nature also has a way of making her own filters. When the clouds roll in, an effective diffusion filter has been created. The haze of a polluted city is, in effect, a filter. It diffuses and changes the color temperature of the light. As a dust storm across the prairie adds particles to the atmosphere that can diffuse light, imagine what volcanic eruptions can do! We have seen news footage on television of villages and towns near volcanic mountains darkened by the ash and soot. That ash and soot will travel thousands of miles via air currents to further diffuse light continents away. Forest fires produce smoke and smoke affects light.

In the photograph of a forest service firefighter battling a major blaze in the Boise National Forest in Idaho, the smoky haze makes it difficult to see the trees behind him clearly, yet adds drama to the scene. To gain access to the front line of this fire for an assignment for *People* magazine, Barry Staver and a reporter went through a forest service fire safety briefing. They also had to wear special fire-retardant clothing, hard hats, steel-toed high-top boots, leather gloves, and carry personal fire shelters.

When metering this type of scene, be sure the flames do not override the meter and cause underexposure. Smoke and fog can throw autofocus cameras into a tailspin. These natural filters diffuse the atmosphere enough to confuse the autofocus mechanisms in cameras, and they cannot lock onto a subject. Manual focus is the answer, of course.

It's in the Bag

It's always a good idea to have reference material along on a trip. Joe Farace keeps camera and flash manuals stored in the big external pocket that covers the back of each Domke bag. The manuals in the pockets of each bag match the gear stored in it. He also likes to keep a copy of Kodak's Reference Dataguide in one of the bags. The pocket-sized book contains information about Kodak film, time zones, a weight and measures' table, a notch guide for sheet film, and even a table of film warm-up times. Next to it is Fuji's Professional Data Guide, which has information on all of their color and black and white films. It's full of useful reference information, including processing specifications for black and white film, and extensive information of filters, such as a Kodak to Fuji CC filter conversion chart. Both

contain suggested exposure settings for common available light situations.

The other front pocket contains a small stack of 3x5 model release forms. There you will find ball point pens (so your newly discovered model can sign the forms) and a Sanford Sharpie marker, which write on plastic without smudging—Joe prefers the ultra fine point—for writing on film, can lids, or whatever. Other useful items include a small sewing kit to repair ripped clothes or to reattach buttons.

Beware of Hockey Pucks

Some spectator sports can be dangerous. Fan stampedes at international soccer games have resulted in many deaths. Runners are either gored or trampled at the Running of the Bulls in Pamplona, Spain each year. The Pittsburgh police set up a small courtroom under the bleachers to deal with the rowdy fans at Three Rivers Stadium during Steeler home games. Line drive foul balls at baseball can be damaging to spectators and photographers alike. By installing Plexiglas shields around ice arenas, the National Hockey League—and all hockey arenas for that matter—have reduced the chance of injury from an errant puck. Fans can still watch the action yet remain safe from the hard rubber projectile that zooms across the ice.

But shooting photographs through the "glass" can cause problems for photographers. The glass is usually about half an inch thick and is often scratched or has wave-like imperfections. Nevertheless, shooting straight through the glass usually results in acceptable images. In order to minimize reflections, you must keep the lens shade up against the glass. Turning the camera too far in either direction results in image distortion. The glass cuts the contrast down a bit, and older glass at some arenas can even require a bit more exposure.

As in the basketball image shown earlier in the book (see Figure 4.5), hockey can be photographed more easily from the seating areas and higher, but these higher angles usually result in less dramatic photographs. Unlike basketball, where players are looking up as they shoot and pass the ball, hockey players are usually looking down at the puck. This photograph was taken during a Colorado Avalanche National Hockey League game in Denver. Each newspaper, television station, and wire service that covers the games have assigned spots along the ice. These photo

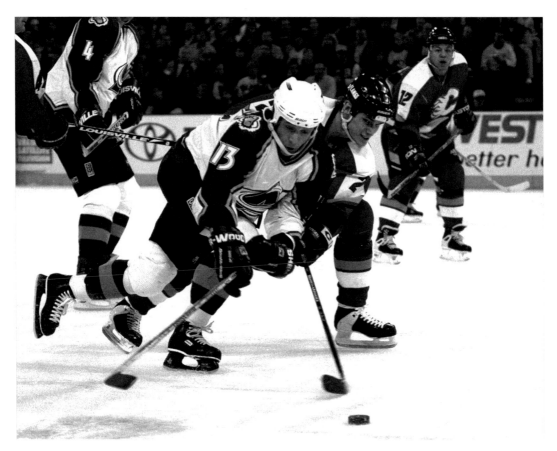

Figure 7.4 The hockey image was produced with a Nikon N-90s and a 35-70mm f/2.8 zoom. Fujicolor 800 film was pushed 1/2 stop. Exposure was 1/400th of a second with an aperture between f/2.8 and 4. Photograph © *The Denver Post*/Barry Staver.

spots are set up to allow shooting without blocking the fans' views. Fortunately, there is light kickback off the ice's surface that will fill in some shadow areas on players and their faces.

Clothes Make the Photographer

A few years ago *National Geographic* ran a story comparing the real life of a staff photographer to the glamorized version featured in the book and film of *The Bridges of Madison County.*

When the question of what they wore on the job arose, none of the shooters admitted to wearing a photo vest like Clint Eastwood did in the movie. "I want to blend in" was a comment often heard. Joe Farace was amused to see that in one of the last photographs in that story—of a couple sharing a tête-à-tête in a Paris bistro—the photographer, clearly wearing a photo vest, is reflected in the window.

Joe owns three photo vests. One is a lightweight cotton vest he purchased from Porter's Camera Store twenty years ago. It has few pockets but when it's hot, it's his vest of choice. He has a fishing-style vest that he hardly wears because it's so heavy and bulky. He usually wears a pre-Gap, Banana Republic vest and didn't think he needed a new one until he saw the Vestrap from Nikon. They call it a Vestrap because it has a built-in, removable, camera strap. L.L.Rue's vest also has a built-in strap, but it is not removable and the vest weighs twice as much as the Nikon's pound and a half. The Vestrap has a cotton shell and six front pockets, along with two side pockets to stick your hands or car keys. What makes these pockets different from what's found in most (maybe all) other vests is that they have Velcro closure flaps and are elasticized so that the pockets actually "hug" whatever you place in them. The pockets are lined with a smooth material that won't snag on parts of your photo gear—such as a Nikon AI lens prongs. Inside the front there are four more pockets, including one with a zipper. The Vestrap also features a padded collar and snap-on shoulder epaulettes. The vented back features a mesh lining to keep you cool and a wide "game pocket" that holds enough film for even the most avid "bracketer."

Other Useful Accessories

One of the best gadgets you can carry on low light shooting adventures is a small flashlight. Any of the micro-sized ones will work. They are perfect for checking camera settings in darkened theaters or on hotel ledges, or to find your way back to the car after the golden hour has passed. Barry Staver used a small flashlight when photographing the assignments for Mormon Temple, the Brown Palace lobby, Clinton and Yeltsin, and the Ice Show.

Metal cameras and bare fingers do not mix well in cold weather. Barry Staver prefers one of those instant hand warmers that fit conveniently into pockets or pouches and will save many

pre-dawn shoots. These would have helped, had he had them, on many assignments, including the Denver City and County lights assignments. Joe Farace keeps a pair of fingerless wool gloves he purchased in an outdoor clothing store in the top pocket of his camera bag. The gloves help keep his hands warm when the weather turns unexpectedly cold.

Some newer cameras do not have cable release access, but you can still create your own. A cable release lets you trip the shutter with less impact and movement to the camera than the traditional fingertip release. By using the self-timer on a camera, you can duplicate the smooth cable release exposure. Some cameras allow two photographs to be taken with one push of the self-timer button. The second exposure occurs five seconds after the first. A fancier way to create your own shutter release is with a remote control cord. Camera manufacturers sell three-meter and longer cords that plug into the camera body with either bare wires or a button at the other end. These cords are designed for remote firing, but can be used close to the camera too. If you need the ultimate in vibration free shooting, don't overlook locking up the camera's mirror, but this is tough to do with a moving subject.

Lens shades are also a necessity for low light photography. In addition to protecting your lens, any time you can prevent non-image-forming light from striking the front element of your lens it will improve overall image quality. Since the conventional rules of shooting with the light source to our backs are being broken, you want to minimize stray light from entering the lens. One of the best protections to have on your lens is a lens hood. Get one designed to be used for your lens. Finicky photographers, like Joe Farace, like to protect their lenses even further by using a lens cap on their lens hood. Who makes a lens cap for lens hoods? Pringles® makes them! Sure, they think they're making potato chip can lids, but those same Pringles® lids snap on many Nikon lens hoods, protecting stuff from falling into the hood and onto the lens.

Other useful resources for low light photography are local newspapers or computer software (shareware, actually) such as "World Clock." Both are helpful for obtaining precise sunrise and sunset times as well as moon phase and moonrise times. Likewise, a compass will aid in properly selecting the point where the sun will crest the horizon in the morning. Yes, it rises in the East, but the exact spot on the eastern horizon varies with the time of year.

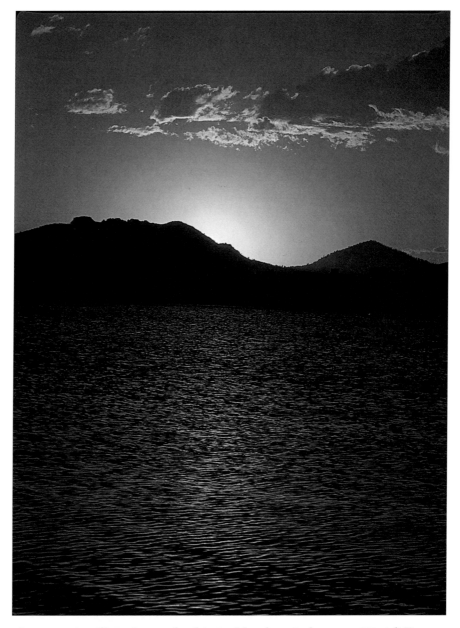

Figure 7.5 Bill Craig caught this "golden hour" shot near Westcliffe, Colorado, while he was waiting for the fireworks (see Figure 6.1) to start. The photo has three nice qualities: the beauty of a sunset; the silhouette of the mountains; and the reflection of the sun in the lake. The exposure that Bill used blocks out some distracting buildings in the foreground. Shot with Pentax 645 with 150mm SMC lens, a Slik tripod, and Velvia 50 film. Photograph © Bill Craig.

Tip from Joe: A Clean Lens Is a Happy Lens

Just as important as the equipment stored in the main pockets of either bag are what can be stuffed into the outer pockets. The front pockets of each of my Domke F-2 bags contain a pack of Kodak lens tissue and a bottle of cleaning fluid. I try to clean my cameras at the end of each day. This includes blowing them out with a small can of environmentally friendly canned air. Bag One also has my "secret weapon" for lens cleaning and is one of the great products I found in the pages of *Shutterbug*. The LensPen features a retractable brush for knocking off chunks of dirt, or whatever, from your photo gear and has a small chamois-like tip on the other end for removing small smudges from lenses. It is especially useful for getting at rear lens elements that are recessed inside the mount.

As the Sun Slowly Sets . . .

Imagine trekking to a perfect "photo op" location in the predawn darkness, then unloading a PowerBook laptop computer on site and calling up World Clock to pinpoint the exact latitude and moment of sunrise. Using your trusty Boy Scout compass—and a Mag Light to see the dial—you find that exact point on the horizon. Then you patiently set up your "sticks" and mount a camera and a fast long lens that will be used to catch the sunrise shot of a lifetime. Then just before you rewind the film from this "golden hour" session, you use your cell phone to pre-order an extra hot latte from the nearest Starbucks™ that you will pick up on the way to your photo lab. *Life doesn't get any better than that.*

A Photographic Filters

Photographers seem to be of two minds about filters: Purists don't like them because they abhor anything that gets in the way between the reality of the captured image and their film. These photographers may own a polarizer, but will only use it for special situations. Others, including myself, love filters because they allow us to change, improve, and modify reality to suit our personal view. This second group of photographers tends to own dozens of filters, even if they seldom use them all.

An Ounce of Protection

Yet, filters have many uses beyond a modification of the way the original image appears in the viewfinder. I know that some photographers disagree but all of the optical experts I spoke with believe it's a good idea to attach a UV or Skylight filter to the front of each lens. Some photographers make it a practice never to put a filter on any lens unless it is to produce a specific visual effect. They feel using any filter, no matter what its quality may be, degrades optical performance and changes focus.

I find a Haze or Skylight 1A filter provides an effective "ounce of prevention" for photographic situations that include blowing dirt, saltwater spray, or crowded situations—such as photographing children with sticky hands. They can protect the front element of your expensive lenses. Another important application is color correcting the lighting in a scene to match the kind of film you are using. This lighting in your photograph may be fluorescent or the kind of intense ultra-violet (UV) light encountered at elevations of 14,000 feet or higher. To bring these images into the same color correct view your brain provides to

Figure A.1 Filters, like these from B+W, can both protect your lenses as well as enhance the images made with them. Photograph courtesy of Schneider Optics.

your eyes, you need filters. A Tiffen Skylight filter absorbs 45.5 percent of the UV light, while a Haze filter provides 71 percent absorption. Photographers, like me, who live at high altitudes may want to use a Haze 2A that absorbs virtually all UV light.

Some long lenses, including Sigma's larger telephoto lenses, are supplied with a built-in protective front glass and don't require a Haze or Skylight filter. It seems obvious that you want to use a good quality filter, but Larry Hicks, KEH Camera's Technical Support Manager, told me he is "constantly amazed to see a poor quality filter resting on a Leica or Hasselblad." High quality filters featuring impressive optical performance are available from B+W, Tiffen, and others. An option to using Haze or Skylight filters is Tiffen's "Clear" filter. It's designed for protection only, is made of clear optical glass, and provides no Ultraviolet (UV) light absorption.

Putting Filters to Work

Several times while on assignment I've had a chance to test my practice of keeping a Haze or Skylight filter mounted on my lenses all the time. One incident occurred when photographing a gymnastic competition between the American and Russian women's Olympic gymnastic team in Denver, Colorado. Even though the Denver Coliseum was lit for ABC's Wide World of Sports, a preliminary meter reading showed F2.8 at 1/250'th of a second at ISO 640. Shooting a few test rolls the day before the event showed that Kodak EPT rated at EI 800 gave me just what I needed.

I was shooting with a Tamron 300 F2/8 lens with it mounted on a Gitzo Reporter. The lens preset focus click mechanism made photographing the uneven bars event a lot easier than it would have been. By tightening the small, preset knob I was able to focus on the near bar and quickly shift focus to the far bar without having to check focus during those fast-paced routines on the bars. The slides that I shot with my Nikon FM-2 and FE-2 during the gymnastics event, while grainy (because of push processing), are sharp. During a break in the action, I glanced at the front of the lens. Right across the middle of the front mounted filter was a giant scratch! I don't know how it happened, but it was much less expensive to replace that filter than the lens it protected.

What Makes a Good Glass Filter?

Filters come in many shapes: There are screw-in glass filters, delicate gelatin filters that drop into holders or lens hoods, and square and rectangular plastic filters designed to fit adapters that attach to different lenses with varying front thread sizes. When shopping for glass filters that have a screw mount to match the front of your lens, there are several aspects of its construction to consider. The glass should be as flat as possible, the color—if any—should be a pure as possible, and the mount should be strong, durable, and not prone to binding or cross threading.

Since filters are placed between your subject and the camera, the glass should be the best quality possible in order to maintain the characteristics that made you purchase the lens in the first place. B+W and Heliopan, for example, use Schott glass from

Figure A.2 Before the front filter mounted on his 300mm f/2.8 Tamron lens was scratched, Farace captured this image. He finished the assignment sans filter, but was much more careful while shooting. Photograph © Joe Farace.

Zeiss which is ground and polished much like a camera lens. Some filters are constructed sandwiching a gelatin filter between two pieces of glass. Over time, the materials used in constructing laminated filters can separate, causing bubbling and pealing—although this never happened to any of my personal laminated filters. The biggest disadvantage of laminated filters is that there are six surfaces to keep flat, which if not accomplished, can reduce image quality. The alternative is to dye the glass when it's in a molten state. The use of pigmented glass means there is no danger of change of color shifting as the filter ages. Keep in mind that all polarizer filters use laminated construction because they have to use polarizing film. To reduce reflectance and the risks of flare and ghosting, most manufacturers coat their filters. Some apply coating to one side of the glass, but Heliopan and Hoya coat both sides. Hoya estimates that their single layer can reduce light reflection from ten percent to between five to six percent. Multicoated filters are also available: Hoya's HMC filters uses twelve layers and Heliopan has fourteen layers to reduce reflectivity even more. Heliopan and B+W mount their filters in brass rings because they cannot bind or cross thread. Hoya prefers aluminum because it is less rigid than brass and can absorb shock better in case of damage to the front end of your filter-protected lens.

The Modular Alternative

Selecting a modular system is much more subject than picking a glass, screw-in filter. If one company doesn't have the glass filter you are looking for in 77mm, you may be able to find it from another manufacturer. Modular systems are different because they have been originally designed to fit many different front thread sizes. These filters are made to fit a standard filter holder that uses various sized adapter rings to allow the holder to fit several different lens and even different format cameras. That means you will only need one starburst—or even polarizer—filter and it will fit both your 35mm and medium format cameras. Even if you only shoot 35mm, the time is long past when camera manufacturers standardized on one filter size on the front of their lenses. You can end up with several different front thread sizes to fit several different lenses. Modular filters overcome the problem of having to purchase many different in size but identical in function screw-in glass filters and only require that you

have inexpensive adapter rings for each different thread size. Where manufacturers of modular plastic filters differ is in the sizes of filters and the type of adapters used, although Tiffen makes glass filters that fit these company's adapters.

Typically modular filters are square or rectangular in shape, although some companies offer round filters too. Also they are more than likely to be made out of plastic. Plastic filters are usually made of the same optical resin material that's in my eyeglasses, so don't let that word "plastic" conjure up the optical quality found in some disposable cameras. Here's a look at some modular filter systems:

> Cokin filters, imported by Minolta, offer two formats: "A" and "P." The A filters are 67mm square, while the P filters measure 85mm x 94mm. A series holders fit lens threads from 36 to 62mm, while P series fits 48 to 82mm. A Hasselblad bayonet and universal adapter are also available. Since there is some overlap, you might end up using both A and P series filters. Cokin offers an adapter that lets Series A users use P filters if the size of the lens permits. The Cokin filter holders permit the use of three filters at the same time, and the company offers a coupling ring that lets you combine to holders for using up to five filters. With all of these filters mounted in front of your lens, a lens hood is a must and Cokin offers one for both P and A series.

> Lee Filters Foundation Kit provides a modular filter holder that can accept up to four 100mm wide filters. Lee filters measure 100 x 94mm. 35mm shooters and others who have coveted the Hasselblad bellows lens shade—which has a filter slot—will want to check out the family of lens hoods from Lee Filters. The Single Filter Hood looks and acts like a Hasselblad lens hood but accepts Lee's series of lens adapters to let it hold a single filter. Lee's Pro Hood was designed for use with Cokin A and P filters. Their Wide Angle Lens Hood is available with one or two filters slots and provides glare protection while reducing any problems with vignetting with really wide angle lenses.

> Pro 4 Imaging puts a completely different spin on filters holders by having a folding system that lets you flip filters in and out in front of the lens. The Pro4 Reflex Hood holds four filters in flexible nylon frames. Filters can be flipped in front of the lens individually or in pairs, and your fingers never touch the filters. Pro 4's own series of filters measure 68 x

72mm, but are available is sizes to fit Cokin, Lee, and Sailwind systems.

Sailwind's Pro Vignetta Matte System has been designed specifically for portrait photographers and includes a bellows lens shade that access up to two filters, along with slip in or magnetized vignetters. This means you can use any of the six different Leon Vignetting kits as well as the Montager set that are available from Sailwind. Adapters are available for 49 to 82 mm along with Bayonet 50 and 60, and Rollei bayonet. Sailwind filters are available in the traditional 75 x 75mm size that gelatin filters traditionally use.

A Basic Glass Filter Kit

While not everybody agrees with the concept, many photographers place a UV or Skylight filter on every lens they own. I find a Haze or Skylight 1A filter provides an effective "ounce of prevention" for shooting outdoors. In addition to protecting the front element of your lens, a Skylight, sometimes called "1-A" or "Sky 1-A" or "KR," filters absorbs UV light and provides a slight warming that I like for films that tend to the cool side. A Skylight filter is useful when shooting outdoors in the shade or on overcast days. Haze, sometime called UV, filters are designed specifically to reduce blue haze caused by UV light. A good quality Skylight filter absorbs 45.5 percent of the UV light, while a Haze filter provides 71 percent absorption. Photographers who live at high altitudes or shoot marine scenes may want to use a Haze 2 that absorbs virtually all UV light. An option to using Haze or Skylight filters is Tiffen's "Clear" filter. It's designed for protection only, is made of clear optical glass, and provides no UV light absorption.

Another practical non-color filter is the Polarizer, which can deepen the intensity of blue skies, as well as reduce or eliminate glare from non-metallic objects. Polarizers are available in traditional or circular versions for use with auto-focus camera—although you should check the manufacturer's recommendation. While you can usually mix and match filters, some popular effects filters, such as Lee and Cokin, are made of optical plastic. When used with a Polarizer, it's a good idea not to place them between the Polarizer filter and the subject. Instead, place them between the lens and polarizer. There seems to be an indefinite numbers of spins to put on polarizers. Many manu-

facturers offer Warm Polarizers that combine aspects of a polarizing filter with that of a warming filter. Hoya offers a circular polarizer made from UV glass to provide the effects of UV filtration and polarization at the same time. Neutral Density filters are available in various densities to absorb one, two, or three stops of light. These can be useful when you want to shoot something at slow shutter speeds (or wide apertures) and you have too fast a film speed loaded. One common problem of digital cameras is they often produce a pale skin tone in portraits. This can be corrected by using the familiar 81A warming filter—Tiffen calls theirs 812—to help make skin look more like skin. Another popular non-color filter is the Enhancing filter that is designed to create brighter, more saturated reds, browns, and orange with minimal effect on other colors. It's the perfect filter for shooting fall foliage.

A Brief Look At Gelatin Filters

While less popular than they once were, gelatin filters are an alternative to glass and optical plastic filters. Gelatin filters are made by dissolving organic dyes in liquid gelatin. The most popular size is 3 x 3 inches, although they are available up to 14 x 18 inches. Most color correcting and colored filters are available in gelatin filter form. Gelatin filters are thin and have a thickness of only .1mm which means they provide excellent optical quality for use in precision photography. This thinness also means they are fragile, and while you can tape them to the front of your lens, like my friend John does, they will last longer if you use them in a Gel filter holder, which are available from various camera manufactures or bellows lens hoods. They used to be inexpensive too, but now you can expect to pay $20 for a 3×3-inch filter.

Color conversion filters make a great addition to your filter kit. The 80 series of blue filters allow you to shoot daylight film indoors under tungsten lighting and achieve correct color balance. The 85 series of orange filters allow you to shoot tungsten film outdoors without color shifts. When shooting under fluorescent lighting, a FL-D (fluorescent daylight) filter is designed to work with daylight balanced film. (FL-B filters which are designed to work with Tungsten balanced film.) The FL-D is a magenta colored filter that, when placed over a lens, offsets the

green cast produced in most fluorescent lighting situations. If you have access to a color temperature meter, you might prefer to use color compensating filters such as 20M(agenta), 40M, or 50M. Flourescents come in a bewildering array of types and shift color as they age, so a CC filter may be the best choice when doing critical work such as photographing interiors. Divers may want to use a CC30R(ed) filter on their cameras to produce warmer, more accurate colors when shooting underwater.

Filters to the Rescue

One of the most challenging assignments for any photographer is to photograph another photographer. In fact, it may be impossible. That's why the two authors had their portrait for the back of this book made by a waitress at Gunther Toody's restaurant. Each month we have a breakfast meeting at *GT's* and it seemed fitting that our "official" portrait be made by one of the staff. This particular images was one of three made with a Olympus digital camera so the waitress and her subjects could immediately preview the image and make our choice.

Joe Farace had an assignment to photograph a photographer using a new Pentax camera for an "image" brochure the company was producing. The art director's concept was to shoot the photographer in partial silhouette at sunset with "a pretty sky in the background." After scouting the location where the shot would be made—in the foothills of Denver—each evening for two weeks, the author and AD would discuss if this was "the day" for the shoot. The weather was most uncooperative and normally sunny Denver produced weeks of flat, cloudy days. Meanwhile, the client waited . . . and waited. It quickly became obvious that if we were ever going to get the shot, we needed to pick and day and just do it.

The solution for adding some color was filters. In this case, Cokin Graduated filters were used. Sometimes graduated density filters have a clear area at the bottom and somewhere around the middle, gradually blending into an area of increasing color or neutral density. Graduated filters allow you to control areas of excessive brightness—such as a sky—to bring them into balance with the rest of a scene by darkening and possibly adding color. The company makes fourteen filters in colors ranging from two grey filters that are simply neutral density filters that take what is there and "kick it up notch" to filters that add color ranging

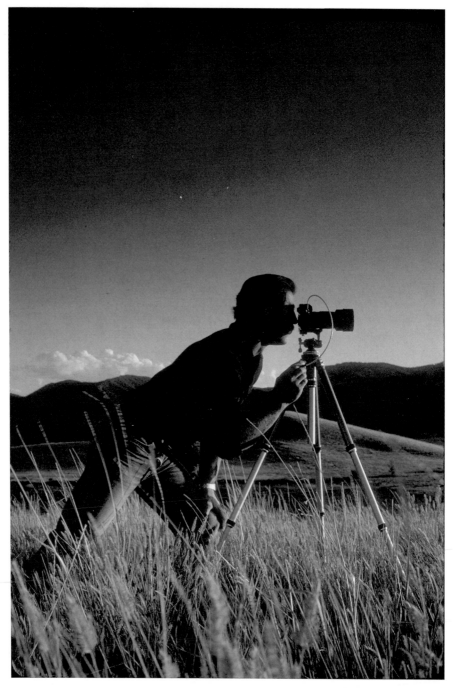

Figure A.3 In addition to bracketing the shots to get varying degrees of silhouette, bracketing also can have an effect on how the Cokin Graduated filters affect the image. In this case, the image was shot with seven of the fourteen Cokin Graduated filters and the Art Director made the final selection, which was made with the Cokin 127 mauve Graduated filter. Camera was a Nikon FM2 with 50MM f 1.4 lens and Kodachrome 64 film. Photograph © Joe Farace.

from mauve to what Cokin calls "tobacco." The colored area of these filters cover less than half of the square filters but the effect can be adjusted vertically and by rotating the filter folder, so there is no need to split the image in equal, and boring, parts. The effect can vary based on the distance of the filter from the lens, the position of the filter in the holder, and the density of the filter used. The effect produced by a graduated density filter is more produced when a wide angle lens is used at small apertures, with an opposite effect made at wider apertures with longer lenses.

Cokin tends to make filters in pairs of the same color, with one having a mild effect while the other, darker one being used to create more dramatic effects. Joe Farace is the proud owner of one of each filters—OK, so he's obsessed with filters—and used almost all but the neutral density filters for this assignment.

B Companies Mentioned in the Book

Adobe Systems Inc., 345 Park Avenue, San Jose, CA 95110-2704, 408/536-6000, fax: 408/537-6000, Internet: http://www.adobe.com

Bogen Photo (includes Gitzo Tripods, Gossen light meters), 565 East Crescent Avenue, Ramsey, NJ 07446-1219. 201/818-9500, 201/818-9177

Bronica, distributed by Tamron, 125 Schmitt Boulevard, Farmingdale, NY 11735. 526/694-8700, fax: 516/694-1414, Internet: www.tamron.com

B+W Filters, Schneider Optics, 285 Oser Avenue, Hauppauge, NY 11788. 516/761-5000, fax: 516/761-5090

Eastman Kodak, 343 State Street, Rochester, NY 14650-0522. 716/724-4679, fax: 716/724-0670

F.J. Westcott Company, 1447 N. Summit Street, Toledo, OH 43604-1821. 419/243-7311

Fuji Photo Film USA, Inc., 555 Taxter Road, Elmsford, NY 10523. 800/755-3854; 914/789-8100, fax: 914/789-8295, Internet: http://www.fujifilm.com

Hasselblad USA, 10 Madison Road, Fairfield, NJ 07004. 973/277-7320, fax: 973/227-4216, Internet: www.hasselblad.com

Heliopan Filters, HP Marketing Corp., 16 Chapin Road, Pine Brook, NJ 07058

Hoya Filters, THK Photo Products, Inc. (Tokina Hoya Kenko), 2360 Mira Mar Avenue, Long Beach, CA 90815. 562/494-9575, fax: 562/494-3375

KEH Camera Brokers, 188 14th Street, NW, Atlanta, GA 30318. 404/892-5522, fax: 404/892-1251, Internet: www.keh.com

Lee Filters USA, 2237 North Hollywood Way, Burbank, CA 91505. 818/238-1220, fax: 818/238-1228

LensPen, Parkside Optical Inc., Vancouver, B.C., Canada. Internet: www.lenspen.com

Lightware, 1329 Byers Place, Denver, CO 80223. 303/744-0202

Lowel-Light Manufacturing, Inc., 140 58th Street, Brooklyn, NY 11220. 800/334-3426, 718/921-0600, fax: 718/921-0303

Macbeth, a division of Kollmorgen Corporation, 2441 North Calvert Street, Baltimore, MD 21228

Minolta Corporation, 101 Williams Drive, Ramsey, NJ 07446-1217. 201/825-4000, fax: 201/327-1475

Nikon, Inc., 1300 Walt Whitman Road, Melville, NY 11747-3064. 800/52-NIKON, 516/547-4200, fax: 516/547-0305, Internet: www. nikonusa.com

Pentax, Thirty Five Inverness Drive East, Englewood, CO 80112. Internet: www.pentax.com

Photoflex, 333 Encinal Street, Santa Cruz, CA 95060. 800/486-2674, fax: 408/454-9600, Internet: www.photoflex.com

Pro4 Imaging Inc., 21 Spragg Circle, Markham, Ontario, Canada, L3P 5W1. 905/294-3041, 800/636-0844, fax: 905-294-4611

Rosco Corporation, 36 Bush Street, Port Chester, NY 10573

Sailwind Photo Systems, P.O. Box 9426, Charlotte, NC 28299-9426. 703/375-8453

The Saunders Group, (includes Benbo Tripods, Domke camera bags, Polaris meters) 21 Jet View Drive, Rochester, NY 14624-4996. 716/328-7800, 800/235-3686

Sigma Corporation of America, 15 Fleetwood Court, Ronkonkoma, NY 11779. 516/585-1144

Sinar/Bron Imaging, 17 Progress Street, Edison, NJ 08820. 908/754-5800, fax: 908/754-5807

Slik America, Inc., 175 Clearbrook Road, Elmsford, NY 10523. 914/347-2223

Tamron, 125 Schmitt Boulevard, Farmingdale, NY 11735. 526/694-8700, fax: 516/694-1414, Internet: www.tamron.com

Tiffen Manufacturing Company, 90 Oser Avenue, Hauppauge, NY 11788-3809. 516/273-2500, fax: 516/273-2557

Index

About the Authors

Joe Farace

Joe Farace is a Colorado-based writer/photographer. He is a graduate of Johns Hopkins University and received his formal photographic education at the Maryland Institute, College of Art in Baltimore. Joe has published over 700 magazine articles about photography and digital imaging. He is the author, co-author, or contributor to twenty books, including Focal Press' *Digital Imaging: Tips, Tools, and Techniques for Photographers*. Joe is an instructor at Photoflex's On-line School of Photography (www. photoflex.com).

He is Contributing Editor for *Photo>Electronic Imaging* and *ComputerUSER* magazines. Joe's monthly column called "Graphics" appears in the *Puget Sound ComputerUSER*. Joe is also Contributing Editor of *Professional Photographer Storyteller* magazine, where his monthly column on digital imaging called "Pixography" appears. He is Editor-at-Large for *The Press*, a screen-printing industry publication. Joe is a regular contributor to *Shutterbug* and *HyperZine* magazines. He lives in Northeastern Colorado with his wife Mary. Visit his website at www.hyperzine.com/writers/joef.html.

Barry Staver

Barry Staver is a photojournalist who also holds a black belt in Taekwon-Do. Starting as a shooter for his college newspaper, he has been a photojournalist for his entire photographic career. After graduating from Colorado State University, he joined the

staff at the *Denver Post*. In 1975, he became an independent photojournalist whose clients include most major news magazines in the country, dozens of trade journals, as well as corporate magazines. Barry's photographs have appeared on nine covers of Time-Life magazines—seven *People* covers, one *Time*, and one *Sports Illustrated*.

Barry has been a Contributing Photographer to *People* magazine, having shot his first assignment for them in 1975 and his first cover in 1976. Assignments with *People* have taken him into thirty-six states and several foreign countries. Barry taught photojournalism at Colorado State University and Metropolitan State College in Denver. In addition to shooting commissioned work, he is back at the *Denver Post* as a staff photographer and assignment editor.

Barry and his wife Jeanette live in the Denver area. They are the proud parents of two outstanding teenage sons.